MURDER & MAYHEM IN THE
HIGHLANDS

HISTORIC CRIMES ON THE JERSEY SHORE

JOHN P. KING

Charleston H London

THE
History
PRESS

Published by The History Press
Charleston, SC 29403
www.historypress.net

First published 2008

Manufactured in the United States

ISBN 978.1.59629.598.8

Library of Congress Cataloging-in-Publication Data

King, John P.
Murder and mayhem in the Highlands : historic crimes on the Jersey Shore / John
King.
p. cm.
Includes bibliographical references.
ISBN 978-1-59629-598-8
1. Murder--New Jersey--Highlands Region--History--Anecdotes. 2. Murder--New Jersey-
-Atlantic Coast--History--Anecdotes. 3. Crime--New Jersey--Highlands Region--History-
-Anecdotes. 4. Crime--New Jersey--Atlantic Coast--History--Anecdotes. 5. Highlands
Region (N.J.)--History--Anecdotes. 6. Atlantic Coast (N.J.)--History--Anecdotes. 7.
Highlands Region (N.J.)--Biography--Anecdotes. 8. Atlantic Coast (N.J.)--Biography--
Anecdotes. I. Title.
HV6534.H54K56 2008
364.152'309227494--dc22
2008041955

CONTENTS

INTRODUCTION

Murder has captivated people since perhaps as long ago as the time Cain killed his brother Abel and it was reported in the *Book of Genesis*. The attraction is not only in the act itself, but also in the motivation, detection, prosecution, trial, sentencing and punishment of the murderer.

Communications media—such as newspapers, television and even plain, ordinary word of mouth—have had significant roles in satisfying the public's desire to know about all aspects of the crimes of homicide, murder and manslaughter, with suicide, perhaps, being the only exception.

In past ages, when murder was an especially uncommon crime, its commission was a cause for extraordinary interest on the part of decent, law-abiding citizens. However, in modern times, as the murder rate throughout the United States has climbed to near crisis levels, especially in poor urban areas, the public's interest has declined in near inverse proportion.

People, unfortunately, have grown tolerant to all but the most highly publicized murders. For example, in this week's local newspaper, which covers two of New Jersey's largest counties, articles on four new murders have appeared on the front pages. While I read the stories with interest, only three other persons out of a dozen readers of the paper showed an equal interest, according to an informal survey. Of these murders, only one received coverage on the major networks' six o'clock news, and that was only because of an alleged connection to an organized crime figure. In contrast, the investigation of Scott Peterson for the murder of his pregnant wife, Laci, and near-term unborn son has been touted by television, newspapers and the tabloids as another "crime of the century." It was as demanding of the public's interest

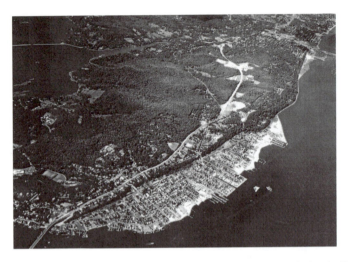

The range of hills of "the Highlands" where the murders took place includes the Boroughs of Highlands and Atlantic Highlands and the Navesink and Chapel Hill sections of Middletown Township, New Jersey. *Author's collection.*

as the TV trial coverage of O.J. Simpson fourteen years ago, also a "trial of the century," for the murder of his wife, or other major trials in the past, such as the Lindbergh Baby Kidnapping trial or the Scopes Monkey trial.

Coverage of real-life murders pales in comparison to that of fictional or fictionalized murders. Television's *Law and Order, Cold Case Files, CSI: Crime Scene, Miss Marple,* even *Monk,* and several other weekly and rerun shows tell of the popularity murder has with the viewing public. A long list of novels, such as *In Cold Blood* or *Silence of the Lambs,* and motion pictures based on these bestselling books, underscores the public's interest in the crime and its desire for gleaning "entertainment" from it, even to the point of being terrorized in the reading or viewing.

Murder & Mayhem in the Highlands is not expected to prompt the same reaction in the reader. It will be enough if the reports, read sequentially or randomly, prove interesting and entertaining, provide some historical insight and appreciation of the period of each case and generally satisfy the reader's desire to know about murders close to home.

This book deals with most of the murders committed in the area covered by the old-fashioned term "the Highlands" (i.e., the Borough of Highlands, the Borough of Atlantic Highlands and the villages of Navesink and Chapel Hill in Middletown Township, New Jersey). They stretch from the 1743 fictional murder of a Captain Kidd associate up to recent times, representing one murder every fifteen years—a desirably low murder rate.

IN SEARCH OF CAPTAIN KIDD'S TREASURE

The Murder of the Old Negro Cudjo in 1743

An old Negro man, named Cudjo, was murdered by an unknown person during the spring of 1743 in the hills of the Highlands of Navesink overlooking Sandy Hook Bay.

BACKGROUND

At the time of the story, 1743, all of Monmouth County was sparsely settled, and the area around the Highlands of Navesink especially so. Here there were just a few low and rude men, mainly fishermen who gathered oysters, clams and crabs for the city market. Generally an uncouth and lawless lot, yet not totally without decency, they eked out their existence living on or near the water in humble huts or caves cut into the hillsides.

WHO WAS CUDJO?

Within sight and sound of the ocean, and overlooking the bay and river within Sandy Hook, there stood a rude log hut perpetually occupied by a huge, old, white-haired Negro named Cudjo. Exactly who this man was and why he was there was a matter of speculation by the locals. Some said that he was formerly one of Captain Kidd's pirate crew and that he was stationed there by Kidd himself, even after the captain was hanged by the British in London in 1701. Perhaps Cudjo had been charged in this wild and lonely spot to guard over treasure buried in the hills or on the beach

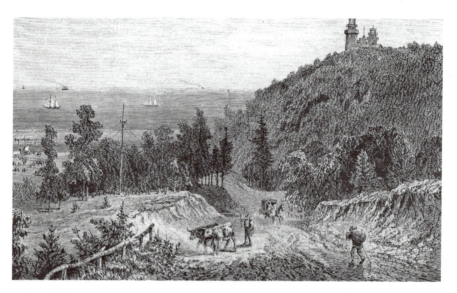

A view of Navesink Avenue (today's Route 36) as it appeared one hundred years after the time of Cudjo's murder up on the hill, where the 1862 Twin Lights stands. Even then the area was sparsely populated. *From* Picturesque America, *1870.*

someplace, or under the hut itself; charged to stand guard until Kidd's return from the grave.

Often the clammers working on the bay at low tide saw smoke swirling above the trees as it rose from Cudjo's hut, and they watched the big Negro moving about here and there, never far from the hut. The older men would sport with younger fishermen, like Davie Matthews or Mike Furman, thrilling them with tales of blood and gore, crimes and depravities committed by the "Big Black" to protect the fabulous treasure he and the "Evil One" watched over.

Matthews and Furman, truly simple minds aflame with visions of grandeur and magnificent wealth, with such talk and fantasy fed their greed for gold and jewels, silver plate, pearls in long strings, adornments of emperors and royalty. Treasure! Buried treasure! There it was in the Highlands, just above them as they strained their backs on hands and knees digging soft clams in the thick, sandy, filthy and cold mud.

After a brutally cold winter, the shell fishermen noticed no smoke coming from the hut and no movement of the big Negro nearby. The simple clammers supposed all manner of reasons for this: He had starved to death. He was Lucifer himself temporarily attending to evil in some other place. The truth was, as sworn by both Matthews and Furman, one of Captain Kidd's ships had come after him, and he left with all the treasure. Matthews declared he had seen a long, sleek, black pirate ship off Sandy Hook during

a recent nor'easter, and on its deck were bleak and doomed-looking men in red caps waving torches as if to someone in the hills.

Rum Gave Them Courage

One night, the same rum that inspired Matthews and Furman gave courage to a group of older clammers, who passed the bottles around and made plans to go up into the hills the next day in a group, armed with rakes and oars.

Before noon, after the stormy night's rains let up and the sky was brightening in the east, some eight of them, not including Matthews and Furman, bravely climbed the hillside to the hut.

A Murder Scene

The first two men to enter the hut let out a yelp and bolted out the small door. Six heads peered inside. Stretched dead on the floor lay the Negro, Cudjo, his head all mashed, with brain leaking out from the broken pieces of the skull. The dust on the hut's floor was caked and encrusted where the brain matter had oozed and dried. The entire hut floor was dug up with a spade, left still in a clump of dirt, no doubt with the object of uncovering the treasure. No evidence of treasure removed, or why and by whom, was to be seen.

The elder and saner members of the clammer group, compelled by common human decency, ordered the others—but not the first two men, who refused to look upon or to touch the well-decayed remains—to prepare a proper grave near the hut.

The last spade of dirt thrown on, one man asked if they shouldn't say a prayer at least, in case the Negro had been a Christian. Two men admitted they knew no prayers. Then one cried out, "Jesus, let's be off from here!"

"Amen," said the rest. And so they left.

Months Later on Sandy Hook Bay

Some two months after the burial, Davie Matthews and Mike Furman were out near the tip of the Hook in shallow water attempting to cash in on the abundance of large blue-claw crabs. They were working from a borrowed

rowboat. Furman, the elder of the pair, his hopes dashed by the empty truth of Cudjo's hut, had become resolved to his poor fate so that the only ambition he had in life was to make a bit of money off the waters' bounty and get a woman, get a bottle and get good and drunk. Matthews, being less attractive and more timid about such things than his friend and fishing companion, hoped only for the drinks.

A Threat of Danger in the Western Sky

It was little Matthews who looked up and out to the western sky and called Furman's attention to the darkening, nasty-looking clouds forming black above the mouth of the Raritan. Both men knew the bay well, from boyhood, and saw they had no time to waste if they were to make it back to their place on the beach below the western reach of the Highlands hills. They set themselves straightaway to the backbreaking work of rowing into the face of the storm. Furman was on the oars with Matthews steering and bailing as needed. Masses of thick, dark and purple clouds were spread from Staten Island to Sandy Hook. They knew they were in for it. The wind was roaring and howling as it raged across the face of the death-dark waters of the bay. Growls of thunder rumbled on the water, and now and again, with increasing frequency, yellow and white bolts of lightning split the black clouds, which were now pouring out floods of rain, filling the boat in measures equal to the salt waves of water from the bay.

"Bail! Bail! Or we ain't gonna make it. We'll not make even the Spout House. Got to turn in to the Highlands, else the Devil'll take us," screamed Furman to Matthews. The water was rolling in long, dark waves, and, above, the seagulls flew screaming for the land. The men, despite their struggle, made little progress to shore. Now the storm came across the bay, ripping, tearing and shredding everything in its path. The men moved slowly against the raging water and wind, and more than once their boat nearly swamped or overturned.

A Worse Thing Yet

As they neared the beach and came under the protection of the hills, the winds calmed a bit, and the water flattened enough for Matthews in the rear of the boat to catch sight of an object floating and bobbing in the water ahead. He called to Furman, who paid it no mind, supposing it a floating

log or dead fish, and resumed his struggle on the oars. Minutes later, as Matthews leaned over the side to dump his bailing pan of water, he jumped back in horror. He saw the face of a dead man looking up at him from his watery grave. The corpse was staring at him as it rose up out of the water on the crest of a wave.

The body had clearly been in the water for a considerable time, a terrible thing to look at. One of the eyes was completely gone from its socket, while the other bulged out with a cold and glassy stare. The lips had either decayed or had been eaten away by the scavengers of the bay, and they left the white teeth gleaming through the ragged flesh. On all other parts of the body—especially the fingertips, where the bones poked through—marine decay had laid its loathsome touch.

Despite the horror of the scene and Matthews's panic and disgust, Furman insisted that they bring the body to land and give it a decent burial. "Can't just leave a man like this, unburied!" he yelled to Matthews. He threw the boat hook into the body and, with a short rope, towed it just feet behind the anxious man at the stern. Matthews was terrified, more frightened of this ghastly cadaver than of the threats from the storm.

Seeking Refuge in the Storm

The men reached land just at nightfall, when the storm lashed out again with more savage fury. They secured the boat and its object in tow as best they could. The two men knew the area well. They knew there would be no safe repose on the flat of the land, where already the floodwaters were rising fast to inundate the entire lowland stretch.

Cold, weary and nearly drowned, they headed up into the hills. Without speaking, the two realized shelter in the Hartshornes was impossible—they were just too far away, on the other side of the peninsula. Only one other site offered refuge from the storm's increasing intensity, and they made for it despite their deep reluctance. They would spend the night in the deserted hut where the big Negro, Cudjo, had lived and died. They had no other choice.

Inside the Big Negro's Hut

At the hut, things were just as had been described to them by the others. Loose dirt was still piled up all about the floor, and the spade used for this

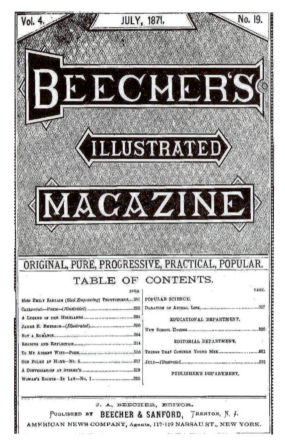

The cover of *Beecher's* for July 1871, from which the story of Cudjo's murder ("A Legend of the Highlands," by William Snelling) was adapted for today's readers. *Author's collection.*

and the burial was leaning in one corner by the door. The old Negro's few worldly possessions lay just as they had been at the time of his death.

It was a forlorn, lonely and uncomforting place, and even the fire they started in the hearth, with its light and warmth, failed to dispel the chill and gloom that hung over the whole area. Matthews, the weaker of the two men, showed his concern and worry in his pale, drawn expression and in his silence as he squatted on his haunches before the flames. He held his head in his hands and rocked rapidly back and forth, with his elbows pressing into his knees and his gloomy thoughts pressing into his whole being.

Furman, by way of contrast, was more philosophical about the situation in which he and his friend were trapped. He comforted himself with serious and frequent draughts from a large, half-full bottle of rum he found on a dusty, cobwebbed shelf. He offered a drink to his friend, who did not respond. He shrugged and, alone, set about becoming totally insensible and oblivious to the storm, their location and all else about him.

In Search of Captain Kidd's Treasure

The storm raged with fearful violence around midnight. Matthews heard a voice. He looked just once at Furman, who was spread out on the ground, saw that the sound had not come from him and turned his gaze back to the fire.

Violence of the Monstrous Storm

The storm howled and clattered around the miserable hut, shrieking and shaking the shelter in protest of its very existence or of the present inhabitants. The tempest turned into a huge savage giant and shook the loose door, pounding at it as if demanding entrance. The winds whipped across the bay's jagged waves and slammed into the hillside's bluffs, shooting fiercely up and lifting objects in its way, trees and brush flying torn away from the land.

Ferocious blasts, wet and frigid, one after another in a series of assaults, screamed over the hillside and howled at the hut and its occupants, "Away! Away!" Matthews cowered in a hunched-up ball. His heart quaked. He shook violently. He dripped soaking wet before the blazing fire with a cold sweat, whose drops spattered and spit as they fell upon the hearthstone.

His feeble mind sensed a foul fiend and its fury, broken loose from the pits of Hell, afoot in the Highlands with a devilish, howling crew in pursuit of lost, escaped souls, whose plaintive wails of woe and despair intensified and blended with the storm winds all about.

There was a tremendous roar of the crashing surf upon the ocean's shore on Sandy Hook and the rushing sound of torrents of water cascading down the hillside in minor rivers and streams.

In the Eye of the Monster Was Heard a Silence

Then, all stopped. There was a momentary lull, a silence, as often happens in a violent storm. Now a new and more appalling sound reached the trembling man's ears. Matthews heard the sounds of human voices, enunciated in inhuman tones. He could not distinguish the words or the meanings. They spoke an unearthly tongue, having the sounds of death and the grave.

Matthews stopped breathing. His heart stood still while he listened. Two beings were in conversation just outside the hut. The fearful dirge of the voices grew louder and louder. A sudden fierce blast of wind tore over the hills and burst open the door.

They entered, two terrible shapes, gibbering and chattering together with a familiarity from the abodes of the dead. Matthews dared not look, yet he envisioned the creatures, and the trembling seized and shook him and terror froze the very marrow of his bones.

One was the Negro, the murdered Cudjo. The earth that filled his mouth, ears and grizzled head dropped to the ground in bits and chunks with worms and earthy grubs as Cudjo exclaimed and groaned his lot, mumbling laments in broken English. The large white sheet that had served as his burial shroud still clung to his terrible form, in some places forced into the decaying, oozing flesh, dark and dank from the noisome contact with the soil.

Close by stood the other fiend, another awful object, the dead man from the beach, dripping wet, dragging after him the rope by which he had been towed to shore. One eye bulged out of his head, the other had been eaten away and the socket oozed saltwater and the green weeds of the river and bay.

THE HORRIFIC CRIME

They sat on stools there in the hut and spoke and laughed in the friendly way of long-parted friends. More soil fell from his mouth as Cudjo boisterously talked and laughed. He took up the bottle from Furman's chest and drank a deep draught. The rum spilled from his lipless mouth and ran in rivulets down his neck and chest. It poured from holes eaten into his cheeks and throat, and gushed from where his stomach once had been. The other man mumbled a gibberish that was characteristic of lost, unburied souls, yet it was comprehended by Cudjo. Then the Negro coughed again, and as the spasm held him, the other man stood up, with fiendish vitality gripping his repulsive, bloated form, and glanced quickly around with his one bulging eye. He saw it by the door. He snatched up the heavy spade and swung it at the unsuspecting Negro. It bonked with a terrific blow to Cudjo's head. The big Negro fell, with a low groan, and the water fiend beat him over the head again and again with the iron shovel, his one eye gleaming with an ominous phosphorescent light. The quivering, mangled form of Cudjo shook one more time and then fell still in death.

Murderous Motives

The murderous fiend started, with great excitement and eagerness, to dig up the floor of the hut, throwing the dirt in a fury of energy. He dug and dug, but he found nothing. His lipless mouth uttered horrid blasphemies at God and curses upon the Negro's soul. Then, without notice of him, the fiend bent over the quivering human ball of Matthews's body and peered into the fireplace. Matthews sensed on the back of his neck the creature's fiercely hot breath, laden with fearful curses. He smelled the rank, biting odor of sulfur, hot and scorching. Poor Matthews's terror intensified. He saw, or imagined that he saw, the disgusting and abhorrent marks of a watery death, burial and decay upon his face and features. Then he drew a deep breath and gagged on the noxious, hellish fumes. Whimpering slightly, he fainted.

Sunrise the Next Day

Matthews lay unconscious all night long, until the sun shining brightly through the hut's door awakened him. He stirred Furman from where he slept in the hut, which was just as it had been when they arrived. Matthews and Furman lost no time scrambling down the hillside and racing to their boat. There, on the beach, lay the corpse of the dead man, still tied with the tow rope, but lying facedown in the sand with the spade protruding from beneath his body. They buried the corpse, leaving the tool stuck in the sand as a marker.

Once in their boat, Matthews pulled hard and fast on the oars until they were a good distance from shore. Then he stopped and looked at the high green hills. The sun was warming. The sounds of thousands of land and seabirds welcoming the day's sun, and the sight of other clam boats coming into Sandy Hook, assured him that all was well again in the Highlands.

"The Most Wanton, Cruel and Unprecedented Murder" of Joshua Huddy

April 12, 1782

Joshua Huddy, Captain in the Monmouth County Militia, was captured March 24, 1782, at Toms River and was hanged by Tories without warrant, at about 10 o'clock in the morning, April 12, 1782, at Gravelly Point, in the Highlands.

Monmouth County Caught in Civil War

During the Revolution, due to its wealth and accessibility to the enemy stronghold on Sandy Hook, Monmouth County suffered from civil strife far more severely than most other places. Loyalist families were threatened, abused, driven out of their confiscated homes and lands and sometimes faced death at the hands of Patriot citizens and soldiers. They took refuge in Loyalist-protected New York, Long Island, Staten Island and Sandy Hook. Joined by criminals and runaway slaves, they became a "miscellaneous scum of miscreants and desperadoes," and they lived up to this description. Groups would sortie out of Sandy Hook at night to plunder, loot and destroy, taking any and all valuables, provisions and livestock, kidnapping Patriot hostages and burning their homes and barns. They became the scourge of good Monmouth people.

Huddy, a Hated and Marked Man

The refugees were vigilantly observed, ruthlessly harassed and continually pursued by Captain Joshua Huddy and his company. Thus, Huddy became

"The Most Wanton, Cruel and Unprecedented Murder"

a revered, almost legendary protector and figure of romance to the Patriots and an infamous object of scorn and hatred to the Loyalists and Tory refugees. Huddy was a marked man, wanted dead, but preferably alive to be made an example of.

A large gang of refugees led by a black runaway slave called Colonel Tye swept down on Colts Neck on September 1, 1780, and attacked Huddy in his home. They captured him after he surrendered to save his home from being burned and hurried back to Sandy Hook, pursued by the militia. Crossing the Shrewsbury at Black Point near today's Rumson–Sea Bright Bridge, Huddy was wounded but escaped. He recovered from his wound, but the refugees did not recover from his escape, for the loss festered in them as they plotted another opportunity to get Huddy.

That chance came some six months after the surrender of Cornwallis at Yorktown, Virginia, on October 17, 1781. Hostilities continued, for there was not yet an armistice or treaty of surrender agreed upon. The situation of the Tories and refugees in Monmouth County was critical; they were desperate with uncertainty about their future and bitter toward the British for having virtually abandoned them despite their loyalty to the Crown. Surrounded by an enemy majority whom they had betrayed and by whom they were despised, their hopelessness and rage led the refugees and surviving Tories to commit acts of vengeance.

Early in 1782, Huddy commanded twenty-five men at a blockhouse at Toms River in lower Monmouth County (in 1850, Ocean County was created from lower Monmouth), an important post in order to protect the salt flats and saltworks, which produced the salt vital for the preservation of fish and meat in the days before refrigeration. A large force of Loyalists and refugees stormed the blockhouse, killing nine and capturing the rest. Next, the enemy burned the stockade, the houses in the town and all the mills and saltworks. With Captain Joshua Huddy as their prize, they took the prisoners to New York City's infamous Sugar House Prison.

Then, on Monday, April 8, 1782, Tory militia Captain Richard Lippincott, originally of Shrewsbury, had Huddy, Judge Daniel Randolph and Jacob Fleming of Toms River, under the ruse of a prisoner exchange, transferred by sloop to the British man-of-war *Britannia* anchored in the Horse Shoe of Sandy Hook, within sight of the Highlands and Monmouth County lands. One of Lippincott's men informed Huddy that he was to be hanged for the torture, mutilation and murder of Philip White. Huddy protested the charge, without success, to the Board of Associated Loyalists, arguing (correctly) that White had been killed after Huddy had been taken prisoner.

THE MURDER OF HUDDY

Under Lippincott's command, Huddy was hanged on Gravelly Point in Highlands, on Monmouth County soil, as a warning and deliberate act of vengeance toward all Monmouth County men. Huddy was given time to prepare himself and compose his will while they prepared the gallows on the branch of a tree near the same roadway along which Clinton's soldiers had marched some four years before as they sought New York via Sandy Hook after the Battle of Monmouth.

Huddy's body was left suspended from the rope attached to the tree. Lippincott and his men knew the local Patriots would find it along this commonly traveled road. In a pocket was his will, and across his chest was a placard: "Up Goes Huddy for Philip White." They knew their message would be relayed loud and its meaning understood very clearly by their enemies throughout Monmouth County.

LAST WILL AND TESTAMENT OF CAPTAIN JOSHUA HUDDY

In the name of God. Amen

I, Joshua Huddy of Middletown in the County of Monmouth being of sound mind and memory, but expecting shortly to depart this life, do declare this my last Will and Testament. First I commend my Soul into the hands of Almighty God, hoping He may receive it in Mercy and next I commend my Body to the Earth. I do also appoint my trusty Friend, Samuel Forman to be my Lawful Executor and after all my just Debts are paid I desire that he do divide the rest of my Substance whether by Book Debts, Bonds,

This window was originally in the infamous Sugar House (a warehouse) Prison in Manhattan during the Revolutionary War. The British held Captain Joshua Huddy and other American Patriots there under inhumane conditions. *Author's collection.*

"The Most Wanton, Cruel and Unprecedented Murder"

An excerpt from George Washington's letter to British General Clinton regarding the murder of Captain Joshua Huddy of the Monmouth Militia. *George Washington's Papers, Library of Congress, Manuscript Division, available online.*

Notes, or any Effects whatever belonging to me equally between my two Children, Elizabeth and Martha Huddy. In Witness whereof I have here unto signed my Name this twelfth Day of April in the Year of our LORD one thousand and seven hundred and eighty two. Joshua Huddy

LOYALIST JUSTIFICATION FOR HUDDY'S MURDER, AN ADMISSION OF GUILT

We, the refugees, having long with grief beheld the murders of our brethren, and finding nothing but such measures daily carrying into execution, we therefore determine not to suffer without taking vengeance for the numerous cruelties; and thus begin, having made use of captain Huddy as the first object to present to your view and we further determine to hand man for man while there is a refugee existing. Up Goes Huddy for Philip White.

DEMANDS FOR JUSTICE

As the word of the murder spread, Monmouth County was frothing with outrage. Over four hundred leading men assembled at Freehold to protest and demand that Lippincott be arrested and tried for murder. General David Forman headed a committee to gather evidence on the facts of Philip White's death. He laid this personally before General Washington, who wrote a protesting and demanding letter to General Sir Henry Clinton in New York.

Head-Quarters April 21st, 1782

Sir:

 The enclosed representation from the inhabitants of the county of Monmouth, with testimonials to the fact (which can be corroborated by other unquestionable evidence) will bring before your Excellency the most wanton, cruel, and unprecedented murder that ever disgraced the arms of a civilized people. I shall not, because I conceive it altogether unnecessary, trouble your Excellency with any animadversions on this transaction—to save the innocent I demand the guilty.

 Captain Lippencut, therefore, or the officer who commanded at the execution of Captain Huddy, must be given up; or if that officer was of inferior rank to him, so many of the perpetrators as will, according to the tariff of exchange, be an equivalent. To do this will mark the justice of your Excellency's character. In failure of it, I shall hold myself justified, in the eyes of God and man, for the measure to which I shall resort.

 I beg your Excellency to be persuaded, that it cannot be more disagreeable to you to be addressed in the language, than it is for me to offer it; but the subject required frankness and decision.

 I have to request your speedy determination, as my resolution is suspended but for your answer.

 I have the honor to be, etc. etc.

Court-Martial of Lippincott

The British commander-in-chief was as much offended by the "barbarous outrage against humanity" of Huddy's murder as he was by the language and tone of Washington's letter. He refused to give up Lippincott due to Loyalist pressures, but he agreed to have him tried in a military court-martial. Lippincott argued that he had been acting under orders from the Board of Associated Loyalists and with the approval of Governor William Franklin. The prosecution argued that the death of prisoners was contrary to all military convention and that neither the board nor Franklin had authority to order it, facts that Lippincott should have known. The verdict rendered by the officers acquitted Lippincott, holding that, although Huddy was executed without proper authority, Lippincott had been following orders.

 Evidence not brought before the judges was that Philip White was a half brother of Lippincott's wife, a relationship that biased any action against Huddy.

"The Most Wanton, Cruel and Unprecedented Murder"

Huddy's home in Colts Neck, New Jersey, near Routes 34 and 537 and today's Colts Neck Inn. *Barber and Howe's Historical Collections, 1844–1865.*

HUDDY'S MURDER HAD INTERNATIONAL REPERCUSSIONS

The words in Washington's letter "I shall hold myself justified, in the eyes of God and man, for the measure to which I shall resort" referred to a practice, in accordance with the laws and usages of war, whereby a Patriot-held British officer of equal rank as Huddy would be selected by lot to be put to death in expiation for the murder of Huddy.

Fortune disfavored nineteen-year-old Charles Asgill—captain lieutenant in the elite Foot Guards, son of the late Lord Mayor of London, bright, witty, handsome and amiable—who had been taken prisoner at Yorktown. His mother, in England, was near frantic with worry, and she used every aristocratic means to free her son from the gallows. Lady Teresa Asgill petitioned the English court of George III; she pleaded for intercession from the Royal Court of the Netherlands; and she personally appealed to King Louis XVI of France, in whose capital of Paris the terms of the peace treaty between Great Britain and the United States were being debated. Washington wrote Congress advocating clemency, and on November 7, 1782, Congress voted that "the life of Captain Asgill should be given as a compliment to the King of France," setting Asgill free.

POSTWAR EPILOGUE

The last remnant of British forces departed the United States in a small group of ships headed for Jamaica on January 4, 1784.

Richard Lippincott went to England seeking compensation for his service and financial losses due to his allegiance to the Crown. He was granted listing as a retired captain, with half pay for life and three thousand acres of land at Toronto, where he settled in 1793 and lived till his death in 1826, well respected by his fellow citizens.

Joshua Huddy's widow and children were left without government assistance or token expression of gratitude by the new United States.

They struggled and survived through their own hard work and with the help of Monmouth County neighbors. Huddy's last surviving daughter, a seventy-year-old widow living in Cincinnati, petitioned Congress for help in December 1836. Congress passed a Resolution of Grateful Remembrance and granted Martha Huddy Piatt six hundred acres of public land and the sum of $1,200, which would have been due Huddy for seven years' service as a captain of artillery. Finally, nearly fifty-five years overdue, Captain Joshua Huddy of the Monmouth County Militia received justice.

HUDDY MEMORIAL

The following bronze inscription was set into a rough granite stone placed at the Water Witch Avenue side of Huddy Park, in the Borough of Highlands, Monmouth County, New Jersey:

Here
Captain Joshua Huddy
of the Monmouth County Artillery
A Prisoner of War
Captured Mar. 24, 1782 While Defending
the Blockhouse at Toms River
Was Hung by Tories without Warrant
Apr. 12, 1782.
The British Authorities Repudiated
but did not Atone for that Crime.
The Sons of the Revolution in New Jersey
Have Set Up this Stone to the
Memory of the Patriotic Victim.

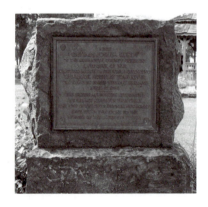

The 1910 monument marking the place in Highlands close to where Captain Joshua Huddy was hanged. It is now located in Huddy Park. *Author's collection.*

"I Am Stabbed...I Am Killed for the Money."

The Final Bloody Words of Albert Moses, August 1, 1857

In the summer of 1857, a friendship developed between Albert Moses and James Donnelly, employees at the Sea View Hotel along the Shrewsbury River in the Highlands. They played many friendly games of cards at the bar and often continued in Donnelly's room until the early hours of the morning. On the night of Friday, September 31, 1857, there were four players: Moses, Donnelly and two sons of New York's surrogate, Mr. Bradford. Moses won a considerable sum of money and stashed it between his mattresses for safekeeping.

As the morning of Saturday, August 1, advanced and dawned, Mr. William Smith, the proprietor, went partly up the stairs and shouted to Donnelly, his bookkeeper, to rise and call the servants. Donnelly's answer was, "All right." Smith soon after called a second time, and again Donnelly's answer was, "All right." Smith finished dressing in his room, and a few minutes later he heard a scuffle and peculiar noise out in the hall. He opened the door, looked out in the hall and saw Donnelly come bounding down the stairs. Donnelly passed Smith and ran out onto the back piazza, where he paced back and forth in great excitement. Smith followed him, and a servant girl watched the scene unfold from a window in the basement.

Smith pressed Donnelly, "What's the matter?" He questioned him three or four times more before he got an answer—Donnelly spurted out, "He's dead. He's dead."

"Who's dead?" asked Smith, and Donnelly replied, "Oh, I don't know!"

Smith left Donnelly on the piazza and ran up to the head of the stairs, where he saw that blood had spurted on the floors and walls. He followed

the blood back to a Mr. Lent's room, number 34, and found Moses lying on Lent's bed, bleeding badly and on the verge of death. Recognizing the owner, Moses said, "Oh, Mr. Smith, I am stabbed. I am killed by your bookkeeper, Donnelly, for the money I won of him last night."

This was a few minutes before sunrise. Mrs. Smith came into the room, and the wounded man said, "Oh, Mrs. Smith, I'm so sorry that this has happened in your house. Donnelly, the bookkeeper has killed me."

Albert S. Moses, 18-years-old, salesman and fill-in bartender, was killed with a knife by James P. Donnelly, physician and temporary bookkeeper, Aug. 1, 1857, in the Sea View Hotel at the Highlands.

This murder became an immediate sensation throughout the Highlands area, where people were reminded of the horrific killing of poor Mrs. Lewis five years before, and in the cities of New York, Brooklyn and Philadelphia, where avid readers, eager for such shocking topics, devoured every word of the murder and trial printed in the papers. Instantly, it became the "HIGHLAND TRAGEDY, wherein the murdered man testified against his slayer practically in his dying, blood spattered, final words."

THE TRIAL

The trial of James P. Donnelly filled ten whole days, from Tuesday, September 15 through Saturday, September 26, during the September 1857 term of the Monmouth County Court of Oyer and Terminer, at Freehold, New Jersey, with Judge Peter Vredenburgh presiding.

Representing the State of New Jersey as prosecutors were Joel Parker and William L. Dayton; acting for the defense were Amzi C. McLean, Joseph Bradley and ex-governor of New Jersey William Pennington.

ADVANCEMENT OF POLITICAL CAREERS

An indication of the perceived importance of this trial—not from a legal, but from a publicity and career-building point of view—can be appreciated from the fact that the incumbent governor of New Jersey, William A. Newell (Republican), was present in the court as an observer and from a brief review of the careers of the men involved on both sides:

"I Am Stabbed...I Am Killed for the Money."

JOEL PARKER, born 1816 in Freehold, was the son of Charles Parker, state legislator and treasurer. He graduated Princeton in 1839, studied law under Chief Justice Henry Green and practiced in Freehold. He was in the state assembly (1844–50) and served as state prosecutor (1852–57). He served as presidential elector in 1860 and was brigadier general of the state militia from 1857. He was a Democratic governor from 1860 to 1866. In 1868, the New Jersey delegation to the National Democratic Convention in New York voted for Parker on every ballot for the presidential nomination. He again served as governor (1870–73), and in 1874 he became attorney general. In 1880, he was chosen to serve on the state Supreme Court and was reelected in 1887. Again, in 1883, he was nominated for governor but declined. Parker died in Philadelphia in 1888.

WILLIAM LEWIS DAYTON, born 1807 in Basking Ridge, graduated Princeton in 1825 and was admitted to the bar in 1830, practicing in Freehold. He was a member of the state council (1837–38) and an associate justice of the Supreme Court (1838–41). He resigned to become a U.S. senator (1842–51), after which he resumed practice in law. He was nominated to be vice-presidential candidate with John Fremont. He was attorney general of New Jersey (1857–61) and served as minister to France (1861) until his death in Paris in 1864.

AMZI C. MCLEAN practiced law in Freehold and, in 1860, was a New Jersey delegate to the Republican National Convention.

JOSEPH BRADLEY, born 1813, the oldest son of eleven children of a New York State farmer, graduated Rutgers and practiced law. He married the daughter of New Jersey Supreme Court Chief Justice Hornblower. He was appointed to the U.S. Supreme Court in 1870 by President Grant and ruled on several cases of extreme national significance. He died in 1892.

WILLIAM PENNINGTON, born 1796, the son of former governor William S. Pennington (1813–85), was a Whig Party governor from 1837 to 1843. He graduated Princeton in 1813 and practiced law before he was elected a New Jersey assemblyman in 1828. He was elected to the U.S. Congress in 1858 and served as Speaker of the House in 1860. He died February 16, 1862.

WILLIAM A. NEWELL, born 1819 in Franklin, Ohio, graduated Rutgers with his bachelor's degree in 1836, master's in 1839 and LLD in 1883, and he received an MD from the University of Pennsylvanian in 1839. His practice

of medicine in Allentown and Immlaystown was interrupted while he served in the U.S. Congress (1847–51 and 1865–67) and while he was New Jersey governor (1857–60). During his term in Congress, he was responsible for the establishment of the U.S. Life-Saving Service in 1848.

THE CASE FOR THE STATE

The prosecutor, Joel Parker, laid before the jury the case for the state. On Wednesday, July 27, Olivera Botelle, a Portuguese man from New York, gave James Donnelly, Sea View House bookkeeper, conversant in Spanish, a deposit of $100 for rooms for his family until he returned from New York on Saturday, August 1, the day of the murder. Donnelly did not place the money in the hotel safe; rather, he kept it on his person, used it and lost more than half gambling with Moses on Friday night. Faced with discredit and ruin, the money had to be restored before Botelle returned. Donnelly was desperate to cover up his minor crime of theft and attempted to do so with the commission of the capital crime of murder upon the unknowing Albert S. Moses as he slept in his bed in a room adjacent to Donnelly's.

Between five and six o'clock in the morning on August 1, people in the hotel heard the cry of "Murder!" and some witnessed a man in his nightshirt, covered with blood gushing from a wound in the neck, pursuing another man in the hall. The wounded man reeled from exhaustion and entered room 34 to lie upon the bed, which would soon become his deathbed.

Help for the gravely wounded Moses arrived in the person of Smith, the proprietor of the Sea View House, and his wife; the owner of an adjacent hotel; two barbers; servants; hotel guests; and two physicians, one, by luck, a coroner of New York, and the other, the suspected bookkeeper Donnelly himself.

In all, a minimum of ten reputable persons witnessed the deathbed accusation of the dying man. Albert Moses remained conscious and coherent for nearly an hour and a half before his death. He accused Donnelly face to face, insisted he was not mistaken and persisted in his accusation even as he was advised of the proximity of death.

According to the reports of physicians before death and in two postmortems, the wound, inflicted by a stiletto-like blade, could not have been self-inflicted; besides, the weapon was not discovered in the rooms or in any other interior or exterior location, and Donnelly could not produce a knife of similar proportions, which he admitted to having had in his possession just two days before.

"I Am Stabbed...I Am Killed for the Money."

Two sets of professionally drawn maps were used to trace the steps of the accused Donnelly as he hastened—in an agitated state, according to the testimony of several witnesses—from one spot to another, seeming to race to pick up some object and run to a privy, to the river and then to his room, where he changed his clothes.

Although the prosecutor never said it, newsmen hearing the state's opening statement described it as "an open-and-shut case" if there ever was one. That opinion was confirmed as they listened to the damaging accounts of thirty witnesses for the state, especially the very moving first testimony:

Mr. John S. Round, sworn.

I live at Florida, N.Y. where I have charge of the Seward Institute. I was at the Sea View on the morning of August 1st. I was a guest and occupied room 29, third floor. I was aroused from my sleep by the cry of murder coming..from near my room. The cry was not very loud....being repeated several times I became alarmed and sprang from my bed, unlocked the door and opened it. I looked into the hall and saw standing in the door a few feet from my room, a man covered with blood, issuing copiously from a wound in the neck, also a large quantity on the floor. I hastily put on some clothes and ran into the hall. I saw the same man within the room, lying on the bed groaning. I felt timid about going into the room alone and went down the hall hoping to get someone to enter with me without result. I returned and entered alone. The man on the bed upon seeing me cried, "Oh! I am murdered!" I asked by whom. "Donnelly." I asked what Donnelly. "Donnelly, the clerk." I asked if he was quite sure and he said, "Yes. Yes."

This evidence, considered along with the following testimony of the proprietor's wife, sealed many a spectator's mind to convict Donnelly, had they the opportunity to sit on the jury.

Anna W. Smith, sworn.

I am the wife of the proprietor of the Sea View House...I heard a servant girl on the third floor calling to Mr. Smith to come, that there was a man bleeding in the hall. When Mr. Smith came down he said there was a man upstairs with his throat cut...When I first entered the room the young man was lying on the bed. He looked at me and said, "Oh! Mrs. Smith. Mrs. Smith, I'm sorry." I said I was sorry too and asked him what was the matter. "Donnelly has cut my throat"...He said he was certain Donnelly had done it. "I awoke from the stab and saw Donnelly standing over me. I chased him to the back of the hall."

AUTOPSY REPORTS

Donnelly's trial was unusual in that two postmortem examinations were performed, one on August 1, the day of the murder, and the other on August 3, after Moses had already been buried for more than two days. The first was done by three physicians, Drs. Edward E. Taylor, Robert Cook and John Vought; the second was done by Dr. Thomas Finnell, at the request of members of Donnelly's family, assisted by the first three doctors and Dr. Edward Taylor Sr.

> *Dr. Edward E. Taylor, Jr., sworn.*
> *I am a practicing physician in Middletown and have been in practice five or six years...I arrived at the Sea View House, the 1st of August last, between 9 and 10 o'clock P.M. I saw the body there in the third story, room 34. There was a wound upon the backside of the neck...It was a puncture wound. Its depth was about six and its width about 2 1/2 inches. It passed obliquely in an upward direction, entered the sternomastoid muscle and passed along obliquely under the windpipe, and touched the cartilage of it. It struck the juncture of the fourth and fifth vertebra and passed toward the shoulder and wounded the gullet in its course...I am under the impression that the jugular vein was severed. The carotid artery was not touched. The thiroid branch was cut.*

> *Dr. John Vought, sworn.*
> *I am a practicing physician...in Freehold and have been practicing for fifteen years. I was at the post mortem examination at Chapel Hill... The jugular vein was severed...This would produce death...A hair breath further and it would have severed the carotid artery. The severance of this is instant death. A few pulsations is all there is after this...Had surgeons been there, it is possible, not probable, that life might have been saved...*

THE CASE FOR THE DEFENSE

The three defense attorneys attempted to weaken the strength of the evidence provided by the state and thus cast reasonable doubt in the minds of the jury members.

Most of the twenty-eight witnesses called by the defense testified to the good character of James P. Donnelly and his family, which they felt was totally foreign to the commission of such a horrible crime. Even entered into evidence was his Georgetown College diploma of July 12, 1853.

"I Am Stabbed...I Am Killed for the Money."

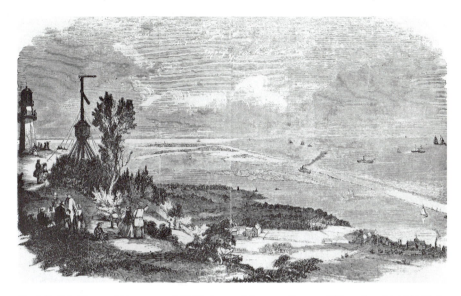

Frank Leslie's Illustrated Newspaper of 1856 shows visitors on Beacon Hill at the old 1826 Twin Lights towers and the Sea View Hotel in the lower right.

More important evidence was Donnelly's years of medical training at, but not graduation from, New York University. The defense appealed to reason that, had Donnelly attacked Moses, his knowledge of anatomy would have led him to inflict an immediately fatal wound, not one that allowed the victim to live and talk for an hour and a half.

They tried to discredit the deathbed testimony—taken in courts as true, given the victim's knowledge of his death being imminent—so well presented by several compelling state witnesses, by arguing that Moses had no religious concern about judgment of his accusations in an afterlife. They set up Dr. Thomas Finnell to do the graveside postmortem and to have him testify to those findings and to the likelihood that loss of major amounts of blood could affect Moses's mind enough to render his testimony suspect.

Based on the testimony of the medically trained barber from Schenck's Pavilion, Augustus Munther, that Moses's wound appeared not freshly inflicted, perhaps two or more hours old, the defense suggested the possibility that Moses woke up and, seeing Donnelly perhaps searching for the money he had lost, took him to be his attacker. Moreover, after accounts of the vast amount of blood lost and spilled on floors, walls, doors, moldings and in the bed where Moses lay, the defense lawyers asked the jury to reason whether Moses's attacker, with whom he struggled, would not have also been splattered with blood. Donnelly could not have been the killer since neither of the outfits he wore that day was bloodstained, according to witnesses.

The Jury's Verdict

The jury deliberated only for an hour and a half. Word spread that they reached a verdict. People scrambled to get back to their seats, and there erupted a wild commotion in the streets as a rush was made for the courthouse. Order was called for. The prisoner and the jury were requested to stand and look upon each other. Then came the ominous words, first of the court clerk, "Gentlemen of the jury, have you agreed upon your verdict?" followed by the foreman, "We have." Next, the fateful question and response came: "Gentlemen of the jury, how say you? Do you find James P. Donnelly, the prisoner at the bar, guilty or not guilty?"

"Guilty of murder in the first degree on the first four counts of the indictment, and not guilty on the fifth."

Sentencing

On October 13, 1857, Judge Peter Vredenburgh sentenced James P. Donnelly to death by hanging. The date of his execution was set for Friday, January 8, 1858.

Appeals

Donnelly's defense attorney, Joseph Bradley, later to become one of the greatest legal minds to serve on the United States Supreme Court, raised serious objections to the charge to the jury given by Judge Vredenburgh, who was already faulted for mishandling the Charles Johnson verdict in 1852, thereby setting the murderer free. First, Bradley cited the judge's bias in stressing only the evidence against the defendant; second, he noted that the judge showed partiality toward the state's evidence; and third, he argued that the judge denied the defendant the benefit of reasonable doubt as to the evidence and encouraged the jury members to consider only if they were satisfied in their own consciences of his guilt, in which case they must find him guilty.

Unfortunately, all appeals filed in higher courts by Bradley were overturned. The defense then turned to the governor of New Jersey, Mr. William A. Newell, and pleaded for pardon, or at least a commutation of the sentence from death to life in prison. Newell, who had been in attendance at the trial, especially on the last day, had already compromised his position as an unbiased judge of last appeal and refused to even consider the plea.

"I Am Stabbed...I Am Killed for the Money."

Desperate Attempts to Save Donnelly

Donnelly was confined in a "murderer's cell" at the Freehold jail and kept under a heavy guard as his appeals evaporated into hopelessness and his ultimate fate approached day after day. His poor sister was in emotional chaos, scarcely able to function throughout a normal day. She was plagued with fainting spells, interspersed by periods of near-hysteria and self-recrimination, and was under the watchful care of the family physician, who prescribed drugs to quiet her and permit rest by inducing sleep. It had been she, his sister Anna, now Anna Cousins, who had seen an advertisement in the city paper for a seasonal bookkeeper at the Sea View House in the Highlands of Navesink. She recommended it to her brother, James, pressing him to pursue it for the sake of his health, urging that the clean, fresh air of the sea would do him great benefit. His condemnation, his death, was on her head—it was all her fault!

Donnelly's aged father was nearly out of his wits with anxiety-choked helplessness and hopelessness over the coming loss of his son. He called James his poor little boy, just twenty-four years old, beautiful, five feet, eight inches tall, well proportioned, with long, black, curling hair, a fair complexion and bright blue, clear and honest eyes. A good Catholic, Irish boy—and alas! That was the reason for the injustice done against him. It was enough that this was the way in the homeland, the poor Irish Catholics being starved and abused by English Protestant lords! Yet this was the United States of America, supposed to be a land of fairness and justice!

Old man Donnelly was desperate. He scraped and begged and borrowed all the money he could from relatives, family friends and friends of Ireland. As an almost last resort, he mounted a campaign to identify, track down and appeal to every one of the twelve men of the jury for mercy for his boy. He appeared as an aged, pathetic old man, a broken father of the condemned prisoner, and, with sighs, groans and tears, he pleaded for hours with each man to sign his name to a petition for the court of pardons to commute his son's death sentence to imprisonment for life. Twelve times he begged; twelve times he departed without a signature.

The true last resort to save his boy was never openly spoken of or even secretly suggested. It just happened, carried out by those accustomed to such actions. People spoke of strange men, aliens no doubt, never seen before, noticed here and there by day and more so by night, watching the courthouse and the jail from the surrounding streets in Freehold. It was generally believed, on good authority, that some $80,000 was floating

around Freehold for the illicit purposes of benefiting a sheriff, court clerk or judge. They found a woman and paid her very well to distract, as only such a woman could, the guards at the jail. Donnelly made his escape, leaping into an awaiting carriage and racing down the road leading to Matawan. Had he made it safe to certain sections of lower New York, from where the Irish servants of the Sea View House had come, he would have been forever protected from apprehension. He did not get more than a bit of the way out of town before being stopped and returned to jail to await the inevitable hangman's noose.

EXECUTION

A detailed account of the hanging (rather disturbing and therefore omitted here) was carried by the local papers, a common practice before these contemporary times in which death penalties have been legally banned in most states, or delayed for a decade or more through lengthy appeals in other states (where legal), and in which modes of execution have become comparatively more humane. Just prior to his execution, Donnelly gave an involved two-hour speech in which he maintained his innocence and faulted a flawed trial and the judge's charging of the jury as responsible for the present execution of an innocent man.

He was to be hanged by the neck until dead on January 8, 1858. James P. Donnelly, indeed, was hanged for more than ten minutes, until all struggling movements and quivering throughout his body stopped and only a limp corpse was left hanging to be examined by several physicians and declared dead.

Two years later, the Sea View House caught fire and burned to just a heap of ashes. Arson was suspected, at the hands of Irish sympathizers from the city and servants from the local hotels, an act of revenge for the alleged injustice suffered by James P. Donnelly.

"The Doctor Was Dead. Blood Was All Over the Place. Murdered!"

The Death of Dr. Maack, August 6, 1873

Dr. G.A. Maack, address and first name unknown, died a violent death in his room at Jenkinson's Pavilion at the Highlands of Navesink the morning of August 6, 1873.

Charlotte Graves, a hotel maid, came racing down the stairs and burst into the back office of the Jenkinson's Pavilion, located in the Highlands of Navesink by the new drawbridge over the Shrewsbury River. James Jenkinson, the hotel owner, ordered her to quiet her high-pitched raving so as not to disturb and alarm the almost two hundred guests booked in the resort that day, August 6, 1873, right at the peak of the summer excursionist season. He asked her again to hush, closing the door leading to the reception area desk. She was red in the face and gasping on her sobs as she attempted to get out her message.

Jenkinson's mind coolly flashed back to the scandal that had afflicted hotels along the river on August 1, 1857. That was the bloody murder of Albert Moses by the doctor and bookkeeper James P. Donnelly. The trial caused a sensation with curious visitors—day visitors *only* from the city—and readers of all the New York and local newspapers. They convicted Donnelly and hanged him the following January in Freehold.

Jenkinson could hardly believe what he was hearing from Charlotte. "The doctor was dead!"

"Quiet, woman!"

"In his bed in his room!"

"Hush, will you!"

"With a knife!"

"Be keepin' your voice down!"

"Blood all over the place!"

"Calm yourself, now, and get control of yourself!"

"Murdered!!!"

"Damnation! Show me and keep your voice low!"

It was true, what Charlotte the maid had been shouting. Dead all right, no doubt about that, and for some time it appeared. It was the front room, giving the best view of the river, and a cool one with good ventilation. A nice room, or at least it had been until now. The owner ordered the maid to lock the door and give him the key.

Downstairs, Jenkinson called Bernard Morris to take a note quickly up to Charlie Havens, the marine telegrapher up at the new Twin Lights. "Be fast about it!" Havens would send a message over to New York asking them to wire Red Bank to get a county detective to the Pavilion as soon as possible. The message suggested there had been a suspicious death but avoided using the word "murder."

Jenkinson was relieved. That late in the day, about half past twelve o'clock, there wouldn't be any city reporters nosing around and upsetting guests with their infernal questions, at least not until the next morning. He sent the maid down to the front bar with instructions for Charlie Lord to give her a bit of brandy for her nerves and for her to keep her mouth sealed and not say a word to anybody, especially guests.

As it turned out, the county detectives were out, and the coroner was not available, either. So William C. Irwin, the justice of the peace in Red Bank, along with a clerk, arrived within the hour and took charge, much to the relief of proprietor Jenkinson. Irwin would be acting in place of the coroner. He surveyed the death scene briefly. He locked the door himself and pocketed the key. He sent Jenkinson's son, George, over to Navesink village to get Dr. LaBaw. He would do an exanimation and establish the cause of death. Next, he spoke to Jenkinson, Morris and Hanlon, and, finally, he interviewed Charlotte Graves, who was by now calmed sufficiently and a touch mellow after two stiff, but inexpensive, brandies.

Justice Irwin empanelled a coroner's jury with men suggested by Jenkinson. James F. Jenkinson himself was on the jury, along with Clark Balcom, Andrew Folk, Frederick B. Clark, Bernard Morris, Ephraim McGuinness, Patrick Hanlon, Michael Fleming, William F. Guire and Morris Smith, all good and lawful men of Monmouth County. They went to see the body in the room just as it had been found and before Dr. LaBaw arrived from Navesink to do his examination of the corpse. This was about three o'clock. LaBaw came down and verbally informed the assembled jury

"The Doctor Was Dead."

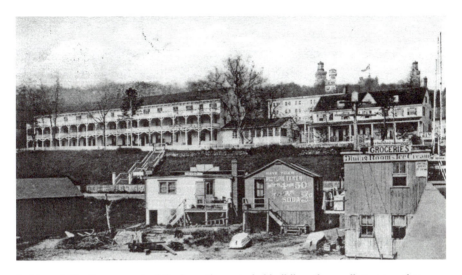

Jenkinson's Pavilion comprised the long, three-storied building, the small structure that held the bar and the large, two-storied house just below the Twin Lights. In this scene from about 1906, the resort complex was called the East View House, which existed until its destruction to make room for the 1933 bridge. *Author's collection.*

and Justice Irwin of his opinion. Suicide, he said it was, and due to loss of blood from a neck wound that was clearly self-inflicted.

Irwin's clerk wrote out LaBaw's statement and had him sign it after he was duly sworn. He paused and asked Jenkinson to get some ice for the body, as he thought it would be a while longer before an undertaker from Red Bank would take charge. Next, he questioned Charlotte, the maid who had discovered the body. The clerk did the same, and she was dismissed. Next, Irwin swore in Morris and took his testimony, primarily to attempt to establish the time of the death and the state of mind of the suicide victim. Justice of the Peace Irwin polled the jury members, who gave a unanimous verdict, and then he drafted the official report in his own hand and asked each man to sign it.

CORONER'S INQUEST

State of New Jersey
County of Monmouth

An inquisition indented and taken at the Highlands of Navesink in the County aforesaid the sixth day of August A.D. 1873 before me Wm. C. Irwin one of the Justices of the Peace of the aforesaid county, acting as coroner, upon the view of the body of G.A. Maack then and there lying

dead upon the oaths of James F. Jenkinson, Clark Balcom, Andrew Folk, Frederick B. Clark, Bernard Morris, Ephraim McGuinness, Patrick Hanlon, Michael Fleming, William F. Guire, and Morris Smith, good and lawful men of the County aforesaid who being sworn and charged to inquire on the part of the State of New Jersey, when, where, how and after what manner the said G.A. Mack came to his death, do say upon their oaths aforesaid that the said G.A. Maack came to his death by cutting his throat with a pocket knife.

Wm. C. Irwin Justice of the Peace

MEDICAL EXAMINER'S REPORT

State of New Jersey
Monmouth Co.

Wm. B. LaBaw M.D. residing at Navesink N.J. being duly sworn deposes and says that he has made an examination of the body of G.A. Maack now lying at the Highlands and that said Maack came to his death by the loss of blood caused by the severing of arteries in the neck and deponent further says that he believes that said injuries were inflicted by said Maack himself with an ordinary pocket knife.

Sworn before me this Wm. B. LaBaw M.D.
6th day of Aug.
1873
Wm. C. Irwin
Justice of the Peace

TESTIMONY OF CHARLOTTE GRAVES

New Jersey
Monmouth Co.

Charlotte Graves being duly sworn, deposes and says that she last saw the deceased G.A. Mack alive on the evening of the 5th inst. at about 7 o'clock and that on the morning of the 6th Aug. inst. she went into the room occupied by the deceased and there found him lying dead with a pool of blood on the floor.

"The Doctor Was Dead."

Sworn to before me Charlotte Graves
this 7ᵗʰ day
of Aug. 1873
Wm. C. Irwin
Justice of the Peace

JENKINSON'S BACKGROUND

James Jenkinson, a native of Ireland, had been living in this country since the middle of the nineteenth century. He was a sixty-six-year-old widower at the time of the Maack case. He and his three sons, William F., James L. and George E. (ages thirty-four, thirty-three and eighteen, respectively), ran the hotel in 1873 with the help of a handful of employees. Of these, Charles Lord, the thirty-eight-year-old bartender, was the most reliable and had been with Jenkinson's Pavilion for a number of years. Besides Bernard Morris, Patty Hanlon and William Kearney—all good, fine Irish lads—Jenkinson had John White from Shrewsbury. Working as maids were Charlotte Graves; Truly Dimmons, a colored girl from New York State; and Truly's seven-year-old daughter, Effie.

Jenkinson's Pavilion had been a Highlands landmark resort for New York City people, both singles and families, since 1868, the year it opened. At the time of the Maack case, Jenkinson had three competitors to contend with. These were Joseph I. Thompson's Atlantic Pavilion, best known simply as the Thompson House or Thompson's, a very large complex; Peter F. Schenck, who ran a smaller hotel close by; and the oldest of them all, the Water Witch House, formerly Colonel Jones's, a half mile to the west on Navesink Avenue. They competed with one another and yet supported each other as well in a symbiotic relationship catering to the tourist and traveler needs of city people to the north, just a brief steamboat ride away. This was the age when—in the Highlands, at least—dining in a restaurant or drinking in a bar always meant going to a hotel. Jenkinson's last year in the Highlands was 1879.

James Jenkinson died in July 1879 at age seventy-two from heart disease in his room at Jenkinson's Pavilion in the Highlands.

JAMES JENKINSON'S CLOSING THOUGHTS

"What a day this has been!" thought Jenkinson as he tallied the hotel's accounts for the day. "At least we'd not lost any guests because of it all—well, just one and he'd been paid up for the week. Tell me now. What worse could happen?"

"WELL, I WILL KILL YOU WHEN WE GET HOME."

Milly Homann's Husband Changed His Mind, August 16, 1888

While the writers of the early newspapers typically and routinely characterized homicides as tragedies, a humane expression at the loss of life, the word *tragedy* is especially appropriate in this case.

> *Adolph Homann, age 24, attempted to kill his mother-in-law, Mrs. Ellen Hayes, then murdered his wife, Melvina, known as Milly, age 21, and with the same gun killed himself Thursday afternoon, Aug. 16, 1888 in Highlands on the grounds of the Twin Lights.*

PREMEDITATION

From testimony of the only witness to the crime—Mrs. Ellen Hayes, the mother of the murdered woman—Coroner Fred Vanderveer, at the inquest held the following Friday (viewing of the bodies by coroner's jury) and Monday (formal inquest), concluded that Homann had clearly premeditated his crime, and not just because he had carried a loaded revolver concealed in his coat. He had convinced his wife and mother-in-law to prepare a picnic dinner, which all three, who lived in the same house in Long Branch, would enjoy together, he insisted, in the Highlands. At first, Mrs. Hayes declined to go along, but Homann was so urgent in his invitation that she reluctantly agreed. Perhaps she tried to avoid irritating Homann, whom she and many others in Long Branch knew to have a violent streak and a badly controlled temper. Perhaps the mother-in-law hoped an outing in the cool Highlands

Jersey Lily & Our Mary

THE FASTEST
PASSENGER STEAM LAUNCHES
IN THE WORLD.

SISTERS TO THE
NOW THEN, HENRIETTA AND SAY WHEN.

Norman Munro's fleet of fast steam launches ran from Red Bank and Branchport to Highland Beach. The *Jersey Lily* was sixty-five feet long and named after the celebrity Lillie Langtry. Red Bank Register, *1888.*

hills might be just the thing to make matters right between the couple, who had been having some terrible times recently. Perhaps she wished to get her daughter out of the house and away from Long Branch to do her good.

They took a carriage to where Homann attempted to hire a sailboat to make the trip to the Highlands. The boatman refused to rent him one, no matter how much Homann offered to pay, unless he took an experienced boatman along to handle the craft. Homann adamantly refused. The coroner concluded that Homann, who knew how to swim sufficiently well, intended to upset the boat in the river, as if by accident, and to let his wife and her mother drown while he saved himself. When this plan failed, he resorted to a bolder, more deliberate alternative.

LEADING UP TO THE CRIME

At the Branchport dock, they boarded the *Jersey Lily*, the steam yacht run by Norman L. Munro. The trip proved pleasantly refreshing and went without incident. When they landed at the Highlands, they walked about halfway up Beacon Hill to the lighthouses. There, Homann started picking at his

wife, called Milly by her family but actually named Melvina. She responded sharply to him, so he drew a revolver from his pocket and pointed it at her, threatening to kill her. Mrs. Hayes made him put it away, after which Homann promised, "Well, I will kill you when we get home tonight."

After their picnic dinner under some trees by the south tower of the Twin Lights, Homann started to quarrel again with his wife. Mrs. Hayes, whose back was turned to them as she was looking out at the beautiful vista below, heard Milly scream. She turned to see Homann pointing the pistol at his wife once again. The older woman ran over and convinced him to put the pistol away. Again, he did so but immediately picked up a stick and began beating Milly with it. Mrs. Hayes grabbed the end of the stick and tried to pull it away. Homann let it go.

Then he drew the revolver for the third and final time. He cocked it and aimed at Mrs. Hayes's head. "The bullet whistled past my ear and my face was blown full of powder," testified Mrs. Hayes, who turned to run away but stopped upon hearing a second shot and her daughter's shrill scream. She turned and saw Milly stagger about forty feet before the younger woman pitched forward and fell upon her face.

Mrs. Hayes ran to her daughter and turned her over. She saw blood running from her left breast. She held Milly as the girl gasped faintly. Within two minutes, Milly died, having been shot through the heart, according to the coroner's report.

Meanwhile, Mrs. Hayes heard two more shots and saw Homann staggering down the other side of the hill, where he fell, with a mortal wound. Two other excursionists from the lighthouse grounds were standing nearby. These brave men had been summoned by the first two shots and pursued Homann, who had begun to run away. Realizing he would be overtaken, he paused, placed the gun to his head and fired. The bullet struck him in the cheekbone and became lodged there. He placed the gun barrel against his temple and fired what would become the fatal shot. Homann died within two hours.

AFTERMATH

Constable W. Nelson Little, of Fair Haven, was posted at the Highlands during the summer season and was summoned from the Merchants Steamboat dock on the river below. He promptly found an assistant and secured the crime scene, keeping guard between the two bodies. Moving off the many curiosity seekers from the hotels below, Little made appropriate notes as he awaited

the arrival of Long Branch Coroner Vanderveer, who had been notified by a telegram sent by the Western Union marine agent, Vinton Havens, in the tower adjacent to the murder. Little took charge of the murder weapon, a cheap .44-caliber six-shot revolver commonly known as a "Swamp Angel." He noted that two unspent rounds remained in the pistol.

The constable had a very long wait, and the bodies lay on the hill for twelve hours, covered by sheets secured from the East View Hotel below. It was about two o'clock in the morning when Coroner Vanderveer arrived in Highlands in his buggy. He was accompanied by a constable and two men from the Morris undertaking rooms in a light wagon to remove the bodies. In the flashing light of the two beacon lanterns, the men uncovered the bodies, finding the murderer lying face down in the dirt just as he had fallen. The body of young Mrs. Milly Homann had been arranged to lay upon her back, her arms folded across her breast and her clothing positioned in such a manner as to hide all but a few specks of red blood. Her mother had done this before going below to a room in the hotel to await the coroner.

The Navesink Light Station, or Twin Lights, at the Highlands of Navesink. This photograph, taken in front of the south tower, shows the grassy picnic area so popular with visitors where the murder and suicide took place. *Author's collection.*

Mrs. Hayes arranged the funeral of her daughter with the Morris Undertaking Parlor. On the Sunday following Milly's death, the funeral services were conducted at St. Luke's Church in Long Branch. Burial was in Branchburg Cemetery.

ANOTHER CRIME

Coroner Vanderveer left his buggy down by the East View Hotel, adjacent to the bridge across the river to Sea Bright. After the bodies were loaded on the wagon and Vanderveer had taken all the required information from Constable Little, he returned to find his horse and buggy gone, apparently stolen by someone. They were returned to Vanderveer's stable by the unknown party by Friday noon. No one was there at the time, and the identity of the thief was never found.

THE MURDERER'S CRIMINAL AND UNSTABLE BACKGROUND

Adolph Homann was born illegitimate in Germany and raised by his uncle. He worked for a bookbinder, and after stealing a number of books in league with an apprentice, he fled to the United States to avoid prosecution. He was sixteen years old at the time. After working in New York for some time, he was discharged for theft and fled to Long Branch, where he held various menial jobs until he joined Morford, Brown and Co. as a porter.

While courting Milly, her mother and father became separated. Her mother favored the marriage, but her father was vigorously opposed to it, knowing that Homann had a violent temper. Milly, only seventeen years old at the time, was afraid of him and refused to marry him. Her mother pressured her. On the evening of the wedding, Milly refused to enter the minister's house. Again, her mother pressured and persuaded her, and the young woman finally allowed the wedding to proceed.

Homann frequently beat his wife, and on the Saturday before the murder he had burned up their marriage certificate (they had been married about four years) and severely beat her. In Long Branch, he was regarded as surly and ill-tempered. He was arrested a short time before the murder for beating a woman whom he accused of interfering with his domestic affairs. Neighbors said that Homann was very jealous and suspicious of his wife, vowing on several occasions to shoot and kill men with whom he imagined she had been intimate, although they maintained that she never received the

attentions of other men. Furthermore, a bitter hatred developed between Homann and his mother-in-law once he started abusing his young wife and the mother realized that the marriage was her fault.

Shortly after his marriage, Homann went into a room at Morford, Brown and Co. where his employers' daughters were gathered. He attempted to portray a peddler, perhaps for their amusement. He carried a bundle of suspenders in one hand and a pistol in the other. With a flourish of the revolver, he ordered them to "buy or die." The gun discharged, striking one of the girls in the stomach. She recovered but still carried the bullet in her abdomen. Homann was tried the following November in Freehold. He pleaded guilty to simple assault and battery, with all parties claiming the shooting was merely accidental. He was fined thirty dollars and court costs, which he worked off imprisoned in the county jail. It was during his time in jail that he became suspicious of his wife and, once freed, began to abuse and beat her.

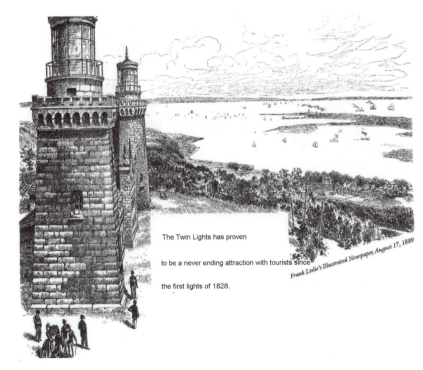

The Twin Lights has proven to be a never ending attraction with tourists since the first lights of 1828.

Frank Leslie's Illustrated Newspaper, August 17, 1889

An engraving from the popular *Frank Leslie's Illustrated Newspaper* of August 17, 1889, shows the attraction of the Twin Lights for tourists. This scene is very near the murder site.

CONCLUSION

The body of Adolph Homann, self-convicted and self-executed murderer of Melvina "Milly" Homann, was buried in Potter's Field at public expense, without church services, grave marker or a single mourner.

TWIN LIGHTS, THE NEVER-ENDING TOURIST ATTRACTION

During an archaeological excavation of the old 1828 Twin Lights towers sites, students found smoking pipe fragments and oyster shells and suggested these were likely left by the many tourists who continually came to the Highlands and its Twin Lights grounds to enjoy the breezes, views and picnic lunches, something still done by tourists today. The existence of the pipes and shell fragments, even without further interpretive information, suggests very frequent visitation by the public during the period of the earlier towers, from 1828 through 1862.

This attraction for tourists is well documented by early illustrations depicting the light towers, the extensive vistas of the Highlands below Sandy Hook, the ocean dotted with ships out to the horizon and twenty ladies, gentlemen and children in groups enjoying the site. An article in one of the local newspapers mentioned the popularity of this site:

Red Bank Register
July 20, 1910

This year as they have for the last 50 years or more, the Twin Lights on the hill are a great attraction. Almost every day the lights are visited and the lighthouse tender delights in taking the new comer up the tower into the revolving lamp where they have a fine view of the ocean and the surrounding country for miles. In the rear of the lighthouse is a large stretch of open ground for basket parties and during the past week over 500 persons have eaten their lunches there.

A GRIMM TALE OF ATTEMPTED MURDER

October 1889

The story of this singular attempt at murder ran in the *New York Times* on October 26, 1889. The crime took place in Parkertown, a hamlet on the river between Atlantic Highlands and the Navesink Highlands. The village was made up of a few cottages, occupied by clammers, and two or three general stores. One of these was owned by Christian Grimm, a grocer, to whom many of the houses in Parkertown also belonged.

> *Christian Grimm, Swiss immigrant grocer, in the village of Parkertown, attempted murder, first with a pistol then with an axe, against Mrs. Cooperschmeid and her daughter.*

"Chris" Grimm, a seventy-seven-year-old native of Switzerland, came to this country some forty-five years before the time of the attempted murder. He came to Monmouth County and worked fifteen or twenty years for various farmers, especially around Marlboro, accumulating "a snug sum of money." With this money, he moved to Parkertown, investing in properties and a grocery store to earn some $25,000. Parkertowners detected a certain peculiarity and quirkiness about old man Grimm, especially when he bought a huge safe, weighing nearly one ton, and had it installed in his house behind the store.

Grimm never married, but he did have a single relative here in America, a man named Cooperschmeid, who came to Parkertown and married a local girl. After her husband's death some time ago, Mrs. Cooperschmeid and her daughter, Elsie, stayed on in one of Grimm's houses. Jacob Johnson, a

This 1920s photograph shows clamming boats anchored near two of the clam processing sheds along the Shrewsbury River at Parkertown, the section of Highlands where a large number of people named Parker lived and earned their livings from harvesting and processing hard and soft clams from the nearby waters. *Clyde L. MacKenzie Jr.*

young, thirty-two-year-old laborer, his wife Henrietta and their two children shared Chris Grimm's house.

It was Johnson who first noted Grimm's deepening emotional disturbance and brought it to Mrs. Cooperschmeid's attention about a month prior to the criminal outburst. Clammers throughout Parkertown were talking: "Keep the wife and kiddies out of old man Grimm's place. He's gone crazy. He is raving about getting rid of a witch that keeps coming after him in the night."

One Saturday, neighbors were horrified. Grimm approached poor Mrs. Cooperschmeid's house. He pulled a pistol from his coat pocket and fired five or six shots through the door and windows into the house, claiming that his nephew's widow had bewitched him.

Come Monday, Grimm returned, this time in daylight, as reported by Mrs. Laetitia Stout, clammer Jesse Stout's wife, and other neighbors who declined to give their names for fear of Grimm's insane retaliation. He was carrying an axe. Grimm swung the axe and chopped the front door to bits. Fortunately, both Mrs. Cooperschmeid and Elsie were not at home, or else, it is thought, they surely would have been cut up in little pieces just like the front door.

A Grimm Tale of Attempted Murder

This 1910 postcard shows the small Parkertown village north of Miller Street, Highlands, where Christian Grimm's properties were located. *Author's collection.*

The man was insane and dangerous! A complaint was lodged against Grimm by his grandniece, and a warrant for his arrest was issued by Justice Henry J. Child of Red Bank. Deputy William N. Little of Fair Haven came over on the *Sea Bird* and took Grimm into custody on the Thursday following the murder attempt, placing him in the Red Bank lockup.

Grimm appeared in court before Justice Child at two o'clock in the afternoon the following day. The judge questioned him but found that his behavior and conduct were so peculiar and irrational that it would be useless to hold him for trial. Therefore, he brought in Drs. Field and Warner to examine Grimm and determine his level of sanity. Both physicians pronounced Christian Grimm a "LUNATIC."

Despite Grimm's prior criminal actions and his declared lunacy, Justice Henry Child unbelievably allowed the crazy man to return home, *alone*, but with a deputy charged to keep him under surveillance that night and until some decided action was taken in the case.

Meanwhile, Elsie Cooperschmeid had her mother's house repaired and made application to the orphan's court for the appointment of a commission to examine her great-uncle's mental state with the intent to have him lodged in the state insane asylum.

MRS. VAN NOTE'S DEAD BODY COMES TO SHORE

June 5, 1904

BON VOYAGE!

It was a beautiful early summer day, not too warm, but with lots of sunshine and just a slight breeze on the waters of Sandy Hook Bay. They had never been out on a boat alone before, just the two of them, but Joseph Van Note convinced his wife—his second wife—that it would be relaxing and a good sport. She had not been feeling quite herself lately, but this Sunday she appeared to be improving. Her dizzy spells had not given her much trouble recently. Mrs. Van Note agreed that it might do her some good and surely would do her no harm.

They walked down to William Roop's place on the water in Belford at Compton's Creek. The walk made Mrs. Van Note uncomfortably warm —she felt overheated from the exertion. As her husband helped her into the boat and she sat down on a coat-covered box in the bow, Mrs. Van Note appreciated how much cooler it was on the water. She smiled. Her husband assured her that the breeze on her face would cool her once he got the gasoline-powered boat moving. It was just a little past noon when Roop pushed them off and waved to them, wishing Mrs. Van Note a joking "bon voyage."

Mrs. Joseph Van Note of Belford died June 5, 1904 under suspicious circumstances, falling from a boat operated by her husband near the Atlantic Highlands pier.

Mrs. Van Note's Dead Body Comes to Shore

The boat moved at a good clip, powered as it was with the little gasoline engine. In no time at all they passed Atlantic Highlands, with its fine homes up on the hillside above the town, and a bit later Van Note pulled into the dock near the bridge at the Highlands. He tied up and went to get his wife some fruit from a vendor just below the East View Hotel. She enjoyed the refreshing fruit and thanked her husband so very much for his kindness and concern for her welfare. Now she wanted to go back home to Belford.

They started back, seated together at the stern, apparently enjoying each other's company. The boat was making fast headway, especially as the wind was blowing lightly out of the east and Van Note had added some naphtha to the engine. When they were just about to pass the Central Railroad of New Jersey's Sandy Hook boat pier, the engine fumes caused Mrs. Van Note some discomfort and, without saying a word to her husband, she got up and headed for the seat in the bow. Van Note was looking down to adjust the engine when he heard a splash. Looking up, he saw his wife was gone. By the time he slowed the craft and brought it back around to the fatal spot, there was no sign of Mrs. Van Note, he said later. There was nothing at all. He waited and looked hard at the surface of the water, squinting and

Joseph Van Note and his unfortunate wife left in a motorboat rented from Roop's Landing here in Compton's Creek, Belford. Today, this deep tidal creek is still a center for commercial fishing boats. This spot is two and a half miles from where Mrs. Van Note lost her life. *Author's collection.*

shading his eyes with his hand against the bright sunlight reflecting off the surface.

He waited some unknown number of minutes further. Nothing. Van Note then started the engine and headed at full speed back to Roop's in Belford. He docked the boat, tied it up and went to tell Roop what had happened, begging him to get some other boats to help search for Mrs. Van Note. Without questioning why Van Note had come all the way back to Belford and not gone to Atlantic Highlands, Roop led the search. Again, they found nothing.

(The above summary is taken from the statement Joseph Van Note gave the authorities.)

THE BODY COMES ASHORE

The early summer heat led a bunch of off-duty soldiers at Fort Hancock to grab their bathing costumes. It was about ten o'clock in the morning. They could have gone to Sandlass's Highland Beach, where they were sure to meet some city or, better, some local girls, but not without transportation. They kept it simple and went down to the bay side of the Hook for a "bath" in the calm, deep water at the Horse Shoe. Within minutes of entering the water and swimming about, they found Mrs. Van Note's body floating face up.

They knew what to do. Two of them dragged it out of the water and up onto the wet sand of the beach, keeping it just as they had found it in the water. The fastest of the soldiers dressed and ran to report the body. A sergeant at the provost marshal's office telephoned the civilian authorities and returned with the soldier to the scene. Within the hour, Monmouth County Coroner Russell G. Andrew, also a Highlands physician, was on hand and took charge of the body, transporting it to Posten's undertaking establishment on First Avenue in Atlantic Highlands.

EVIDENCE OF FOUL PLAY

The condition of Mrs. Van Note's body gave rise to serious suspicions on the part of authorities and others about town who had heard talk, even before the coroner could report his medical findings and the inquest jury could consider the evidence. The woman's jaw was bruised and broken, as was her right wrist, perhaps in an effort to defend herself. Then there were the band-like marks on her neck. All this led to the conclusion that Joseph Van Note was not telling the truth, or at least not the full truth.

Mrs. Van Note's Dead Body Comes to Shore

To darken suspicions further was Van Note's odd behavior. Why had he gone all the way back to Belford to get help and report what had happened? Common sense would dictate that he should have landed at Atlantic Highlands first. Was he stalling for time, trying to hide a criminal action?

VAN NOTE DISAPPEARS

Added to this was the mysterious disappearance of Van Note on the day of his wife's death. That night, Van Note did not stay in his home, understandably enough, but rather bunked with a neighbor named William Maby. Sometime during the night he skipped out, leaving the key to his own house on Maby's kitchen stove, but not leaving a note of explanation of why he left and where he was going. This, in the minds of many, was the action of a guilty man, especially since he knew the search for his wife's body was to be resumed on Monday.

At about five o'clock on Monday morning, Van Note was spotted near Matawan. It was thought that he had gone by train to Philadelphia, where he had relatives. Calls and wires to the police there showed he had not met any relatives in that city.

Things looked very bad for Van Note. He had vanished Monday and was not seen or heard from Tuesday, Wednesday, Thursday or Friday. Surely, this was the manner of a murderer. An honest, innocent man would contact the authorities immediately. Coroner Andrew sent word Monday to Belford, telling Van Note that his wife's body had been found. Word came back that he was not there. Word also came back that he had spoken to another neighbor—not Maby—the morning he skipped out, telling where his house key was to be found in case his wife's body was recovered and brought to his house. Bizarre behavior—no sane, intelligent man would act like this!

VAN NOTE COMES BACK

On Saturday afternoon, June 11, Joseph Van Note returned to Belford, with his son George, from Bay Head. Van Note had gone there to see him that very day. Where he had been up until that point remained a mystery. He claimed he did not know. As soon as his son told him that authorities had been searching for him all week, he returned home. Constable John Brewer clapped the handcuffs on him so he would not disappear again. He was placed under arrest, taken to the Atlantic Highlands lockup and held without bail as a flight risk. The next day, Sunday, he was escorted by two detectives to the

Monmouth County Jail in Freehold, where he was to remain under tight lock and key until the convening of the coroner's inquest in Atlantic Highlands.

His Good Neighbors

The situation looked bleak for Van Note. Everything seemed stacked against him, pointing to him as a guilty man, a man who had murdered his own wife. But not one of Van Note's Belford neighbors spoke against him. They said to detectives, to reporters, to anyone with ears, that Joseph Van Note could not have killed his wife. They swore that the two had been devoted to each other and were a very happily married couple, seemingly happier than most married men and women in Belford in 1904. Not a word of reproach was ever heard spoken by Joseph against his poor, sickly wife. She suffered from dizzy spells and the faints and had been under the care of a physician for some time. Joseph was fixated on her; he treated her lovingly and with great devotion despite her illness.

Poor Mrs. Van Note, they said, not quite forty years old, an Englishwoman without relations in this country, a rather well-featured lady. It was bad enough to die as she did, but worse now that her good husband was accused of causing her death. No, not Joseph Van Note, honest and hardworking. It was no wonder to those who knew him that he was in a daze after his wife died and could not tell where he had been and what he had been doing. As for not turning himself in sooner, well, poor Mr. Van Note could not read or write so he would not have learned from the papers that he was wanted by the police. Poor Joe Van Note was rather slow of wit at times, and no wonder! He had been struck by a bolt of lightning many years back and had never been quite right since, suffering from awful headaches.

Many said that the marks on the Mrs. Van Note's body could be easily explained. A collar made tight from the water could account for the so-called "rope" marks on her neck. As far as the broken jaw and wrist, the boat's propeller, the propeller of another boat or the paddles of a steamboat could have caused these injuries. Surely, she had experienced a dizzy spell or a fainting fit and, next thing she knew, was in the water headfirst.

Sentiment Against Him Grows

Some of the positive and supportive sentiment in Belford began to erode, and many more people had, in their minds, already tried and convicted

Van Note of murder. If they could get their hands on him, they would have hanged him from a lamppost. Guilty as hell, they swore.

Before Constable Brewer took Van Note to the county jail in Freehold, he took him to James Martin's barbershop on First Avenue, Atlantic Highlands, for a shave. He was totally unkempt and should have had a bath as well as a shave; however, there was no time for that, and the other inmates at the jail would not care. Word got out that Van Note was in the barbershop. A large crowd was outside waiting in the street for him to exit. They wanted to see him, supporters and accusers alike. His accusers said an innocent man does not run away. His supporters said a guilty man does not return voluntarily. His constable escort, with pistol drawn, said it was up to a jury to decide.

Coroner's Inquest and Jury Verdict

Coroner R.G. Andrew, MD, held his official inquest in the firehouse on Center Avenue, just a few houses from First Avenue. He first selected and

Henry M. Nevius (1841–1911) served as a major in the Civil War in Lincoln's Cavalry and under General Custer. He lost his left arm in battle. He served in the New Jersey Senate from 1888 to 1890 and practiced law in Red Bank. In gratitude, the City of Red Bank cast Nevius's image in the war memorial statue in the center of town. *Author's collection.*

swore in his jury of six local men, S.T. White, George E. Jenkinson Jr., Elverton Doughty, George Clark, Frank Price and J. Mortimer Johnson. The coroner was joined in the inquest by the Monmouth County prosecutor of pleas, the famous Henry M. Nevius of Red Bank. Such was the considered importance of the case. Nevius brought along Edwin J. Wise, who made a highly accurate transcript of all proceedings. Van Note had retained an attorney, Edmund Wilson of Red Bank, to be present at the inquest, something considered a wise move given the fact that he had been arrested under the charge of murdering his wife.

Coroner's Findings

Nevius called the first witness, Dr. Andrew, the coroner. Dr. Andrew related the medical evidence he found on the dead woman's body. He found a slight abrasion on the right of the head just at the hair line. The face was swollen and very congested, and there was a flow of blood into the right eye and under the eyelid. Around the neck, there was a dark purple and blue line. The lower jawbone was fractured at the point of the chin, which he thought had been caused by a blow under the chin. The back of the right hand was broken and discolored.

Nevius asked the doctor for his best professional opinion on the cause of death. He replied that he thought the direct cause of death was drowning and that the indirect cause of death was violence done before the body entered the water. He went on that, in his opinion, the marks on the body were not made after the body entered the water—there would have been lacerations had it been struck by a propeller or boat paddles. He found no water in the lungs, indicating that the woman did not breathe after entering the water; however, he admitted that lack of water in the lungs was not absolute proof.

Van Note's lawyer, Edmund Wilson, asked the coroner if he had examined the woman's brain, heart and pelvic area to see if there were indications of a disease that might have caused her death. Dr. Andrew had not done this, and he admitted, when asked by Wilson, that these examinations would have been necessary to determine whether the cause of death had been drowning or some other undetermined medical condition.

Van Note was present at the proceeding but did not testify, as was the normal practice at inquests. He sat stoically and completely expressionless, with his face revealing not the slightest emotion throughout all the testimony.

By four o'clock, the inquest was at an end. The coroner charged the jury and had it retire to another room to deliberate and form a verdict. In less

than half an hour, the jury returned, and the foreman, Samuel T. White, handed the coroner the verdict, which he read aloud. Van Note's son, friends and neighbors held their breaths.

State of New Jersey
County of Monmouth

An inquest indented and taken at Atlantic Highlands in the County of Monmouth the 17th day of June nineteen hundred and four, before me, Russell G. Andrew, one of the Coroners of the said county, upon the view of the body of Mrs. Joseph Van Note then and there lying dead and upon the oath of various witnesses, do find that the said Mrs. Joseph Van Note came to her death on the 5th of June due to accidental drowning.

Joseph Van Note was released from custody and returned to his home with friends and neighbors. As he left the fire hall, he repeated to a *Red Bank Register* reporter what he had said to his neighbor, Maby, many days before, "It is pretty hard lines to lose your wife and then be accused by the public of killing her."

Did Van Note Kill Again?

Strange circumstances again involved Van Note, for the last time. Was it natural causes or suicide that took the life of the murder suspect Joseph Van Note? As he was illiterate, on September 9, 1904, Van Note dictated to his neighbor, William Maby, a note that was to be given to his son George "in case anything happened to him."

Van Note's landlord, who was concerned about the house Van Note rented by the month, stopped by that same day to check on things. He entered, and upstairs he found Joseph Van Note, cold-dead yet still seated on a commode, looking as natural as in life, his upper body upright and one elbow resting on a knee, with sixty dollars in his trousers pocket. There was no sign of foul play. Downstairs, the landlord found a new suit of clothes, a new white shirt and collar, all laid out neatly on a sofa.

Despite the findings of the coroner's jury that Mrs. Julia Van Note died of accidental drowning, Prosecutor Henry Nevius took charges to the grand jury to consider on Monday, September 11, without knowing that Van Note was dead. The jury voted to indict him for the first-degree murder of his wife. Joseph Van Note's death killed the indictment, but not the many questions and suspicions of his Belford neighbors.

8.

"MAY GOD FORGIVE US!"

The Baby Callahan Murder, January 5, 1907

Michael Callahan lived on a farm in Chapel Hill on King's Highway East, not far from Portland Road. He was a sixty-seven-year-old hardworking and hardheaded Irishman who ruled his farm and family with an old country strictness that often brought fear into the hearts of his wife and family members. Living in the house were his Irish-born wife, Catharine, aged sixty-two; son John, thirty-two; and four maiden daughters—Ella, thirty-four; Tillie or Matilda Jane, twenty-nine; Lizzie, twenty-four; and Ada, twenty-seven. Another unmarried daughter, Emma, had died at age thirty-two, seven years before, and was buried in Mount Olivet Cemetery near Headden's Corners.

> *A baby, born alive to Ada Callahan, in Chapel Hill, died Jan. 5, 1907 due to head injuries inflicted by one or more members of the Callahan family.*

Mrs. Callahan blessed herself time and again, holding a rosary tightly wrapped about her right fist. "Thank God," she thought and might have blurted out to the rest of her brood, who were standing about in the farmhouse's front room, all caught up in a dread bordering on hysteria. "Jesus, Mary and blessed Saint Joseph! Thank God Mr. Callahan is up in his sickbed with the grippe and a high fever. Quiet now. Not a word. Mother of God, now none of that bawling. I'll be dealing with you all later. Now's the time to be on with it. May God forgive us! Pray none of this reaches your father's ears."

"May God Forgive Us!"

Mrs. Callahan sent the farmhand, Andrew Sacks, whom everyone just called "the German," down to Atlantic Highlands with instructions to bring back Dr. Henry Hendrickson, the family physician, as fast as possible.

Dr. Hendrickson's First Visit

Dr. Hendrickson had been tending to the Callahans since he started practice in town in 1889. He woke quickly to the pounding on the door below, answered it and told the German to wait a minute. They arrived at the house at about three o'clock on the morning of January 5, 1907. As he entered, Mrs. Callahan said, without otherwise greeting the doctor, "This is an awful thing, Doctor. My daughter has just had a baby!"

He was shown to a room upstairs, where Ada Callahan lay in a bed, and was told that the afterbirth had yet to come away. Hendrickson assisted in the delivery of the afterbirth, which, according to his testimony before the coroner's jury, was approximately fifteen inches long.

Next, the doctor demanded to see the baby. Mrs. Callahan and the other sisters hesitated and appeared too confounded to speak. Their mother told the doctor that the baby was dead and buried. She said it had been born after the German left to go and get the doctor. She said that the baby had been buried down in the field on the side of the hill. The doctor told them he would return the next day to check on Ada and to see the dead baby. He was taken back to town by the German, who appeared completely unaware of the nature of the medical crisis. "Typical female problems," was what the doctor told him.

Dr. Hendrickson's Second Visit

Dr. Hendrickson returned, as he had promised, the following afternoon of the same day, at about four o'clock. He checked on Ada, whose health was improving. He wanted to see the dead baby. The Callahan women again hesitated. Mrs. Callahan explained that since it was still daylight outside, they would not care to dig up the baby and bring it into the house, concerned that they might be seen either by Mr. Callahan upstairs or by the German, who certainly would inform the mister. They begged the doctor to return on Sunday for the baby's body, saying that they would retrieve the body in the dark and have it for him on Sunday.

Lizzie Callahan took the doctor aside and spoke to him in hushed but emphatic terms. "Now, Doctor, if you would keep this all quiet and not

speak of the matter, we would pay you well for it. Now you let father pay you in the regular way, but, doctor, we will see that you are paid for this, but you must be quiet. My father has the grippe and is very sick, and he must not know anything about this matter." Dr. Hendrickson had never been offered a bribe before. He said nothing, left the house and appreciated the overwhelming fear controlling everyone living under the roof of Michael Callahan's house.

Upon returning to the Callahans' the next day, Sunday, January 6, at about four o'clock, Dr. Hendrickson was taken upstairs by Mrs. Callahan and two or three of the sisters. The sister Ada was still in bed. One of them brought into the room the baby, still in the box in which they had buried it. "Here is the baby in the box," she said.

One of the others asked the doctor, "What are we going to do with this baby? We can't bury the child on the farm. We thought perhaps we would go down after dark and bury it in the graveyard." (It is likely that she were referring to Bay View Cemetery, which was closer than the Catholic cemetery at Headden's Corners.)

The doctor offered to take the baby, not out of kindness and sympathy for their plight but out of a concern to examine it and to bring the matter to the attention of the authorities. He did not mention his reasons, and they did not ask, being relieved that they were to be rid of the dead baby. They agreed to let the doctor take the baby after dark. He promised to return at about eight o'clock that evening.

In the meantime, Dr. Hendrickson had contacted by telephone the county detectives working out of Red Bank. Detectives Jacob Rue and Elwood Minugh arranged to meet the doctor in front of the Chapel Hill post office at ten minutes before eight. So as not to frighten the Callahans, the doctor and the detectives, in separate carriages, drove past the house at a distance. The doctor then turned around and went back to the house to get the baby. As he drove up, one of the women picked up the box, which they had left resting on an old tree stump, and handed it to the doctor, who put it on the floor of his buggy. At this point, all the Callahan women were gathered outside with the doctor in the middle of the road. The detectives arrived, and the Callahans told them the same story they had told the doctor on his previous three visits.

Lizzie and her mother described to the detectives just how the baby had been born. They claimed that the baby had been born dead, as the mother, Ada, stood erect in the middle of the front-room floor. They maintained that the baby had been born with such force that its head struck the floor, not crying or showing any signs of life. They all agreed that it just lay there on the floor dead and that no one dared touch it for about half an hour.

"May God Forgive Us!"

After Dr. Hendrickson left, the county detectives warned Mrs. Callahan and her daughters, Matilda Jane, Lizzie and Ella, that they were under suspicion and that they would be required to attend the coroner's inquest at a time and place to be determined. They panicked. Mrs. Callahan clutched her prayer beads tighter. They knew that Mr. Michael Callahan would have to be told. Indeed, he had to be informed right then since his wife and daughters were being placed under arrest and taken down to Justice Grover C. Williams in Atlantic Highlands. The judge held each of them under a $500 bond to appear as witnesses at the coroner's inquest. Michael Callahan's blood was boiling in anger, first at being deceived by his family and second at having to pay out $2,000 in bonds.

The doctor went down to Atlantic Highlands and stopped at Posten's funeral rooms on First Avenue. He handed Amzi Posten the box containing the dead baby, telling him he would return the next day to do an examination of the remains.

The Autopsy

Dr. Hendrickson asked Dr. John H. Van Mater to assist at the postmortem on Monday, January 7, between ten and eleven o'clock. The report, which was made part of the evidence in the coroner's inquest, noted that the baby was female, full term, twenty inches long and weighed seven and a half pounds or a bit more. It noted that the baby had an expression on its face of having cried. This indication of having been born alive was countered by the fact that the baby's ears were "closely approximated to the sides of the head," which was an indication of being born dead.

Coroner's Inquest

Monmouth County Coroner William E. MacDonald of Bradley Beach presided over the inquest at two o'clock on Saturday, January 12, 1907, held in Atlantic Highlands on the upper floor of the firehouse, called the "truck house," located on Center Avenue close to the main street, First Avenue. Because of the serious nature of the case, Monmouth County Assistant Prosecutor A.J.C. Stokes assisted and aggressively interrogated the leading witnesses, attempting to get at the true facts and lay the foundation for an ultimate prosecution of a capital offense. He assembled and swore in a jury composed of "good and lawful men" from the borough. They were Samuel

T. White, John L. Sweeney, Charles Frost, William H. Posten, H.V. Tompkins and George Y. Schmidt. The list of the witnesses called to give evidence included Mrs. Callahan and her daughters Ella and Matilda Jane, who spoke in defense of themselves, maintaining that the baby had been born dead, just as they explained to Dr. Hendrickson and detectives Rue and Minugh. The German, Andrew Sacks, spoke of routine matters pertaining to his fetching the doctor at the order of Mrs. Callahan. Amzi Posten was called to establish the security of the remains prior to the autopsy. Detectives Rue and Minugh testified to the events leading up to the receiving of the body and its transport to Posten's. Ira Antonides, the pharmacist; John Snedeker, the chief of police; and William Burke of Chapel Hill gave testimony on fairly minor matters. The most important and damning evidence was given by Dr. Henry Hendrickson, supported by Dr. Van Mater, concerning the medical findings, which indicated that a crime had been committed. In all, the doctor's testimony filled forty-two typed pages.

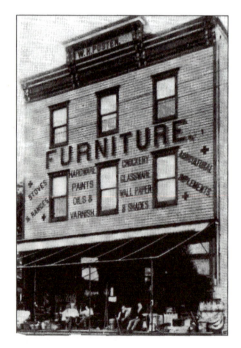

Harry Posten's store, shown here circa 1900, located at 92–94 First Avenue, Atlantic Highlands, served the area not only for its hardware needs, but also for its funeral arrangement needs at a time when embalming was done at the rear of this shop and wakes and funerals were conducted from the home. *Atlantic Highlands Historical Society.*

"May God Forgive Us!"

Report of the Autopsy

Dr. Hendrickson testified that he and Dr. Van Mater noted on the baby's body no external signs of violence. They did notice a little swelling on the right top of the head. A circular incision allowed exposure of the skull, which showed it had been fractured. Upon removal of the damaged portions of the skull, they noted a significant amount of blood. They concluded that the fracture and bleeding, brought about by external force, were the probable cause of the baby's death.

Next, the doctors performed a hydrostatic test of the baby's lungs to determine if it had been born alive or dead. They explained that the lungs were removed and placed in a basin of water. Since they floated, it was a certainty that the baby had breathed—it had been born alive.

Now, Assistant Prosecutor Stokes asked Dr. Hendrickson a series of questions that focused on the probability that the baby had been born in bed and had not dropped out of the mother as she was standing erect in the Callahan front room. Stokes wanted to know the length of the umbilical cord left on the baby: three and a half inches. He added this to the fifteen inches of afterbirth: eighteen and a half inches from uterus to the floor. It was not likely that the baby fell out of the mother and hit the floor.

Stokes kept after the doctor, asking if he noticed any blood or birth-water stains on the floor. Hendrickson had not noticed anything. Stokes asked if there were any stains in the bedding when he examined Ada Callahan the first time. There were none noticed; however, the mother's lower extremities down to her ankles were pretty well covered with blood. This, he said, could be consistent with either a bed delivery or a standing delivery. Finally, Stokes asked whether a woman who had delivered standing and then was put to bed immediately would have left stains in the bedding. Common sense and the doctor agreed that there should be stains. Stokes was figuring that the mother and sisters had changed the bedding before the doctor arrived, that the baby had been born in bed and that they were all guilty of attempting to cover up the baby's manner of death.

Instructions to the Jury

At the conclusion of all testimony, Coroner MacDonald charged the jury and explained *manslaughter*, the unlawful killing of another person without malice expressed or implied. Then he explained *voluntary manslaughter*, the same as murder but without malice as a constituent element of the crime; and *involuntary manslaughter*, the unintentional killing of another.

61

Verdict of the Coroner's Jury
State of New Jersey
County of Monmouth

An inquest indented and taken at Atlantic Highlands in the County of Monmouth the 11th day of January, nineteen hundred and seven, before me, William E. MacDonald, one of the Coroners of the said county, upon the view of the body of an unnamed female infant then and there lying dead and upon the oath of various witnesses, do find that the said unnamed female infant came to her death on the 5th of January at the hands of Mrs. M. Callahan, Matilda Jane Callahan, Lizzie Callahan, and Ella Callahan, and we determine the crime to be Voluntary Manslaughter.

In witness hereof, as well as the said Coroner, and as well as the said Jurors, have to this Inquest set their hands and seals on the day and year aforesaid, at the place aforesaid.

When Michael Callahan of Chapel Hill died a very rich farmer and businessman at age eighty in 1917, he was buried with his daughter Emma, who died seventeen years before him. The graves in Mount Olivet Cemetery were marked with this rustic monument, made of "peanut" stone from Callahan's farm, now long fallen into ruin. There is no record of the burial of the baby in this case. *Author's collection.*

"May God Forgive Us!"

William MacDonald
Coroner
1. Samuel White 2. John Sweeney 3. Charles Frost 4. William Posten
5. H. V. Tompkins 6. Geo. Y. Schmidt

After the delivery of the verdict, Detectives Rue and Minugh obtained arrest warrants from Justice Edward Wise of Red Bank. They drove to Michael Callahan's and arrested his wife and daughters on charges of manslaughter. Mr. Callahan asked Minugh where they were to be taken, what would happen next (grand jury) and how much their bail bond would cost him ($1,000 each). The women climbed into Rue's carriage, and they drove off. Michael Callahan gritted his teeth and uttered not a single syllable to any of the women.

Afterward

The Monmouth County prosecutor overrode his assistant, Stokes, and decided not to make a presentment to the grand jury in its February term after he interviewed the women charged in the coroner's inquest and thoroughly read the document. He felt that guilt could not be established for any one of the women and considered it best not to subject the mother of the dead baby, whom he judged not quite right in her mind, to public testimony in court and public castigation in the press.

9.

Murder in the Heart of Town

When Booze and Blood Flowed Free, May 10, 1925

Atlantic Highlands was usually thought to be a thoroughly peaceful and safe place to live. However, one other especially tragic murder took place right in the heart of town, not far from reputable businesses, homes of good, law-abiding people and three major houses of worship. While the crime received little or no attention in the town newspaper and never actually made headlines in the New York City newspapers, it was covered by papers in surrounding communities. The articles were not long, as the murder was likely considered just one of a number of gangland-related crimes along the Jersey Shore, the likes of which law enforcement officers and county and state prosecutors never really had great enthusiasm to solve and prosecute.

> *George Richards killed his sister-in-law, Mrs. Andy Richards, the night of May 10, 1925, in her home when she refused to go for a ride in her husband's big sedan with him and two men in black suits and hats.*

Things like this murder just happened, and, if the truth be told by God-fearing Christian people attending services in the Baptist, Presbyterian and Methodist churches, the victim probably got what was deserved, and the murderer and the murdered person surely would face another worse punishment before God.

Murder in the Heart of Town

Long after Prohibition ended, clammers would frequently rake up whiskey that had been dumped overboard by rumrunners being pursued by the Coast Guard. At times of exceptionally low tide, kids in rowboats could make a profit salvaging this abandoned treasure. *Author's collection.*

A COUPLE IN A MARRIAGE OF CRIME

There was a husband and wife at the heart of this crime of murder. Before the murder was committed, the two were thickly involved in another sort of crime for several years. This was the age of national Prohibition, beginning January 20, 1920, and ending December 5, 1933, when possession and sale of prohibited "contraband" or liquor was actively prosecuted by federal, state and county officers of the law, including the U.S. Coast Guard, since so much of the illegal whiskey was moved over open water, from Keyport to Highlands to Long Branch, and especially at Atlantic Highlands.

However, before "rum" became illegal, the husband and wife had a nice family-run business in downtown Bayonne, New Jersey. They were proprietors of a retail liquor store, while living at 121 Linnet Street in a modest rented home, caring for the wife's widowed old mother, Isabel Dooris, and a displaced teenage niece, Julia Cogan. They even hosted one of the store workers, a nice lad of twenty-one years named Bill Halloran.

MAKING AN EASY LIVING—WHY NOT?

A life on the edge of proper society, a life of crime, was the furthest thing from the hopes and desires of Jennie and Andy Richards. However, for them, like so many ordinary law-abiding men and women on the shores of Highlands and Atlantic Highlands, liquor dealing, rumrunning, bootlegging—whatever you call it—was a victimless crime, which, as was seen later, was a slippery path to a criminal shoreline dotted with dead bodies, usually their own.

In Bayonne, Prohibition put the Richardses on the welfare lines—almost. Thank God they never had any children. It must have been tough enough for Andy Richards to provide for his wife, Jennie, and her mother and niece. He was nearly forty years old. What else could he do to earn a living? What else did he know how to do? He clearly loved his family, to a point, and he had a brother, George, and two sisters named Anna and Evelyn. They were all fairly close.

A HAPPY HOME IN TOWN

Connections and a bundle of cash saved from the liquor business operation would have brought them to Atlantic Highlands, where they bought a "modest home," just a three-thousand-square-foot "cottage" on Garfield Avenue in the early Prohibition and rumrunning days along the shore. They lived there under the law enforcement radar for quite some time. This was the grand home of the Roberts family patriarch, Nathaniel Roberts, when all Atlantic Highlands was farmland, years before it was developed into a real town and later a borough. The house stood on property bordered by First and Third Avenues to the west and east, and East Lincoln and East Garfield to the north and south, close to 10 East Garfield Avenue, today a vacant lot. The Richardses bought the property about March 1, 1923.

The city papers covered all the incidents of rumrunning. The local papers covered most of the actions, especially the raids by authorities and the murders. The *Atlantic Highlands Journal* did not cover the homicide related here, perhaps because it was too close to home or perhaps out of fear of retaliation. The Asbury Park, Long Branch and the Red Bank papers covered all bootlegging actions and activities in depth.

Murder in the Heart of Town

LIFE DURING BOOTLEGGING DAYS

Highlands native Ann McNeill, living on Navesink and Valley Avenues, left us a subjective summary of the times:

> Prohibition made so many changes in our peaceful little town. It became a Mecca for rum runners who came to take advantage of the many hidden coves where boats could be unloaded unseen. As for the natives, greed and excitement overcame the law abiding nature of many as they joined the ranks of the outlaws.
>
> High powered boats put out to sea in the darkness to meet up with large boats waiting off shore. They transferred the cargo and raced for shore hoping to out run the Coast Guard. However, they also had fast boats and guns too. Often I woke in the night to the sound of gunfire and wondered what neighbor's son would not be coming home the next day. One such case was a young man named Kadenback. He left a wife and child.
>
> The Coast Guard was not the only one with guns. Armed hijackers toured the highway and sometimes a cargo from Highlands changed hands more than once. Sometimes there was blood shed.
>
> A young couple from Newark, the Bill Smiths, rented the garage apartment across from our back gate (on Valley Ave.). His older brother, Neil, rented a house farther up Valley Ave. They were both active bootleggers and had many young men helpers, well dressed and polite. One day word was passed around that there was going to be a raid. Two of the well-mannered young men arrived at our back door and asked if we could use some wood. With three wood-burning stoves, of course we could. They went away and returned with a load of wooden liquor boxes which they proceeded to break up and stack up in our barn. With the evidence disposed of, we had fire wood for a long time.

A FIRST ARREST, BUT NOT THE LAST

The first notice of Andy Richards running afoul of the anti-liquor law came early in the Prohibition era, on the evening of Thursday, October 4, 1923. A state trooper just happened to be in Atlantic Highlands when he spotted a large sedan with six cases of Scotch whiskey. There were two men in the car moving at a good clip down the road. He ordered the driver to pull over and stop. The order was obeyed. Andy Richards was the driver and owner of the car, and beside him sat Patrick Burnett, both of Atlantic Highlands. Richards

was held on $1,300 bail, while Burnett's bail was $300. The car was being held on $1,000. All these were paid in cash by James Shannon of Atlantic Highlands, and the men were released. They drove away in the big sedan.

Andy Richards may have been fond of music and theatre, judging from the grand homes he owned in Atlantic Highlands. The second place he bought was a grand Victorian summer cottage with three floors, a dozen spacious rooms and expansive porches, capped with a cupola, perched on the bluff in Middletown above the town of Atlantic Highlands. It was blessed with cool water breezes and a gorgeous vista of Sandy Hook Bay and New York City in the distance. For Oscar Hammerstein, the grandfather of the great composer Oscar Hammerstein III, the house had been a refreshing summertime retreat.

THE BIG BOOTLEG BUST

For Richards of Atlantic Highlands, and for many frequent residents in Prohibition days, the mansion on the hill was the operational heart of traffic in illicit liquor. It was a perfect location for the rumrunning gangs, ideally located for a powerful radio station and antenna wires, situated on the wooded hillside yet offering a clear view of the water across to Sandy Hook. Bordered by Southside and Fairview Avenues to the south and north, and close to Portland Road and Serpentine Avenue, it gave easy escape should the need arise. And that need did arise at 4:30 p.m. on October 16, 1929, as 130 state and federal "dry agents" raided thirty places simultaneously along a two-hundred-mile path. The hillside mansion was their objective number one as it was bootleggers' headquarters, with supplies, records and, most important of all, the illegal radio, detected weeks before, used to direct the rumrunning speedboats and supply ships with a businesslike precision. The names of many of those arrested and indicted in the big sweep were well known in the Highlands area: Alexander Lillien, William Lillien, Harold Lindauer, Andrew Richards, Louis "Louis the Wop" Caruso, James Feeney, William Feeney, Thomas Ross, "Buff" Marson, William Marson, Alexander Bergona, Richey Burgunzi, Vito Calandriello, Thomas Calandriello, John "Two Gun Johnny" Calandriello and Herman J. "Blackie" Black.

Besides the raid on the Hammerstein mansion, the government agents hit three sites in Highlands—a house at 296 Navesink Avenue, the Villa Ritchie at 88 Portland Road and the Albion Hotel (formerly the Tuxedo Hotel) reputed to have been the headquarters of the selling agents of the rumrunning syndicate.

Rumrunners plying their trade aboard a sailing vessel from Canada anchored offshore by Highlands, beyond the reach of the law and thus brazened to pose and flaunt their activities. *Author's collection.*

Richards and all of the others indicted and brought to trial were acquitted of all charges. Evidence was thrown out since it had been taken illegally, without proper search warrants. The state failed to prove its case against the remaining handful of defendants. Men on the jury were unwilling to convict men reputed to have been so vicious and retaliatory in their treatment of one another.

Running Rum in Fast Boats

Andy and Jennie Richards were involved in a very serious incident on the night of January 17, 1925. Coast Guard patrol boat number 2319 was off Sandy Hook when the three men aboard, Commander Urban Kilbride and guardsmen L.B. Koch and James C. Moore, spotted a boat moving away from them at a very high speed. They pursued. Voices in the boat were carried by the wind, mocking the patrol and daring it to stop them. Moore fired a shot from the patrol boat's large gun. The fleeing rumrunners kept going. Two more shots rang out. The rum boat cut its speed and its passengers yelled, "You hit one of us!" Moore boarded the boat. There were two men onboard, the wounded man and another who drove the boat. It was identified as

launch K-11509, registered to and owned by Jennie Richards, wife of Andy Richards, of West Garfield Avenue, Atlantic Highlands. It held thirty-five cases of whiskey. Just before boarding the patrol boat, the unwounded man opened the seacocks to scuttle the launch, in an effort to suppress evidence against them and the boat's owner.

The crime did not end there. Much worse was to follow. The Coast Guard took the severely wounded bootlegger to the army hospital on Fort Hancock, where emergency medical attention was given by the doctors there. They said that regulations prevented keeping the man there and that he needed to be taken to the Long Branch hospital if he was to be saved from bleeding to death.

At this point, something irregular took place. The other prisoner was given permission by Coast Guardsman Moore to phone the hospital to arrange for a car to come to Sandy Hook to take the wounded man to the Long Branch hospital. A car arrived, they loaded the bleeding man into the rear and Moore and the other prisoner climbed in. The car sped off, crossed the bridge at Highlands and continued along the roads through Atlantic Highlands and into Leonardo.

It is a puzzle why Moore did not realize Long Branch was directly to the south of Sandy Hook along the ocean, keeping it on his left. Near Belford, Moore supposedly objected that they had driven off the proper route, the car stopped and, out of nowhere, six men surrounded the car, pulled Moore out and beat him with blackjacks. He claimed that he feigned unconsciousness to save his life. The attackers drove off in the original car. Moore was treated by a doctor in Belford and then walked to Perth Amboy, took a ferry to Staten Island and then to Coast Guard headquarters. He did not report the attack and escape until hours later in headquarters. This was strange.

Mrs. Andy Richards told authorities she knew nothing of the speed launch, not where it was kept, not who used it or why. She had just returned from Miami, Florida, and maintained her complete innocence.

Not Going for a Ride Got Her Killed

On the night of May 10, 1925, Jennie Richards was in her home on Garfield Avenue. Names for "cottages" were all the rage. We do not know what name Andy Richards had for it. The Atlantic Highlands police, however, called it a crime scene.

Her husband was not at home. Andy Richards was hiding out in Canada to avoid apprehension by federal, state and county authorities. He was wanted for

having in his possession a wagonload of whiskey, for having contraband liquor in his home and for assaulting a coast guardsman, James Moore, during the night scene related above.

George Richards, Andy's brother, was a frequent visitor to the home, as were unknown and unspecified male individuals, often at night, sometimes at very early hours of the morning. They drove big sedans with big and powerful engines.

It was Sunday evening, already dark. Three men from New York and a woman identified as Mrs. Julia Persell, age twenty-two, of Leonardo, were in the parlor with George Richards and Mrs. Jennie Richards. They were later said to have been partying—drinking illegal booze supplied by the same rumrunner means previously described.

George left the parlor, saying that he and Jennie were going to go for a drive. She hesitated. He urged her, demanding that she go along. Jennie went to the entrance hall closet and got on her light fur coat. They supposedly had a brief whispered conversation. It grew louder and became angry. Jennie Richards shouted, "No, I'm not going riding with you!"

She must have seen that a big black car had already pulled up outside the front door. It was owned by her husband, Andy. Two men were in it, likely men she did not know and did not trust.

Jennie Richards refused to be physically moved. There was a scuffle. She turned to take her coat off. Then there was a shot. Jennie Richards fell to the floor dead, with a bullet through her heart. The .38 slug passed right through her body, went through a wall and landed on the floor of the adjacent room.

George Richards had killed Jennie Richards, his sister-in-law, at close range, as proved by powder residue left on the body. He obviously had the pistol on his person at the time. He supposedly yelled out, "God, I don't know why I shot her!" as he threw the weapon into a bureau drawer in the hall. He ran out, jumped into the car and sped off with the two men.

George Richards hid out for a week to avoid being arrested. Andy Richards, in Canada, told reporters, who informed him of his wife's murder in his home by his own brother, that he planned to return and give himself up in order to help locate his wife's killer.

QUESTIONS ANY REASONABLE PERSON WOULD ASK

Was Jennie Richards to be taken for "a gangland ride," never to return or be found again? Was she suspected of turning against kingpins in her

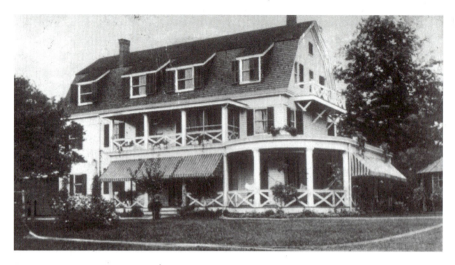

Robert B. Mantell's "Brucewood" was purchased by Andy Richards for his second wife, who likely could not live in either of Richards's first two grand homes where murders took place. *Atlantic Highlands Historical Society.*

husband's organization, or even against him, especially in regard to the K-11509 launch incident?

Was it a spur-of-the-moment killing, enhanced by drinking, on the part of George Richards? Or was Richards planning to plead guilty—after advice from his brother through associates—to a lesser charge of unpremeditated manslaughter, figuring on a few years in prison?

Did George Richards surrender himself because he feared being located by his brother and what he might do to him?

Was James Moore, the coast guardsman, complicit in the rumrunners' escape? Could he have been so unaware of the location of Long Branch? How badly was he hurt? Why wasn't he killed to silence the only witness? Why did it take him so long to alert authorities of what had happened?

George Richards had good lawyers by his side when he appeared before Supreme Court Justice Frank T. Lloyd on December 15, 1925, pleaded guilty to the charge and was sentenced to prison for a term of from four to seven years.

AFTERWARD

After George Richards served his prison sentence, he and his brother Andy remained close, and once Prohibition was repealed on December 5, 1933, Andy Richards opened his establishment on the southwest corner of First

and Center Avenues, known to all locals as Andy Richards' or Andy's Place. It is now the site of the Memphis Pig Out restaurant.

The second Mrs. Richards (her name was Lulla) may have objected to residing in the home where the first Mrs. Richards had been killed, especially with the murderer now released from prison and frequently around.

So Andy Richards purchased his third home for $16,100 at auction on April 27, 1931. It was the old Mantell estate, including all furniture and household contents. He had been renting the place for a short time. A fire broke out, a tragedy for theatre history, at the old Brucewood, destroying almost all the costumes, props and scenery used by Robert B. Mantell in his Shakespearean plays. Firemen from the Robert B. Mantell hose company managed to save just one trunk, containing shoes, swords and costumes. They were taken out and distributed to the firemen as souvenirs. Mrs. Mantell was en route to finalize the sale when the fire broke out.

Over the next thirty years, Andy L. Richards continued to reside in this home until his death on November 28, 1964. His estate was quite large: $5,000 was given to each of his twenty-four grandchildren; his wife, Lulla Seely Richards, received the majority of the remaining; and his children, Jeannette McMurtrie, Georgette Dunn, Pauline Sage, James Elmer Richards, Harold Elmer Richards and Andrew L. Richards Jr., shared equally in the rest. He was also survived by his two sisters, Anna McGloin and Evelyn Hoffman, and his brother, George Richards.

His funeral was at Posten's and a requiem mass was offered in St. Agnes Church by Pastor Michael Lease. Burial took place in Miami, Florida.

Not long after his death, Richards's widow sold the estate to St. Agnes Church, whose pastor, Michael Lease, planned to use the house as a club site for parish organizations and as a summer reading school. He announced that the house would receive a new name, Daemen Hall, in honor of the founder, Magdalen Daemen, of the Franciscan Sisters of Penance and Christian Charity, Stella Niagara, New York, the sisters who taught at St. Agnes School since 1924.

A Witness Saw Nothing as Herbert O. Meisterknecht Was Murdered

November 14, 1927

Herbert O. Meisterknecht, successful inventor and entrepreneur, of 85 Navesink Ave., Highlands, was murdered in his Shrewsbury Ave. workshop and office at precisely 1:30 P.M. on Monday, Nov. 14, 1927 by an unknown assailant.

An Extraordinary Case

The death of Meisterknecht was most unusual from the very outset for five reasons, to be explained for the reader in the text that follows: 1) there were two widows; 2) one witness to the very shooting and killing actually testified that he saw nothing; 3) the slain man was on the verge of becoming a millionaire two or three times over in 1927, when being a millionaire was something remarkably unusual; 4) at the funeral, two heiresses tore at each other tooth and nail, both verbally and physically, over the casket holding the deceased man; and 5) Monmouth County detectives failed, once again, to bring a murderer to justice.

Victim's Background

Herbert Meisterknecht, forty-three, and his wife Sophie had moved to Highlands some three years before. They loved the town because it provided Meisterknecht, the successful inventor, machinist and engineer, with a lovely, spacious home on the hillside overlooking Navesink Avenue and a well-

outfitted workshop at the end of Miller Street, practically on the river, all with easy access to the city by train or steamboat. Sophie especially loved the situation, for it gave them seclusion from prying eyes and questioning mouths and, most important, allowed her husband to perfect his "little gadget," expected to make them both very wealthy.

THE MURDER AND THE WITNESS WHO SAW NOTHING

That fatal Monday, about eleven thirty in the morning, the murdered man had returned with his wife from Atlantic Highlands after a visit to his dentist, Dr. Thomas McVey. He told his wife that he would do some work in his shop and office and probably return for lunch a little after one thirty. He mentioned to a neighbor that, despite the dental work, he had never felt better in his life.

The inventor had his friend, lawyer and financial investor, Peter J. Olde of Elizabeth, on the telephone. They were talking over plans to travel to Fort Wayne, Indiana, to negotiate with a firm interested in his "gadget." Meisterknecht had developed a device that would precisely measure the amount of gasoline pumped at a gas station into an automobile. It was going to revolutionize the gasoline pump and delivery industry. As they were speaking, Olde heard five shots ring out, then a thump and silence. Frantic and fearing the worst, he hung up and phoned Frank Seigfried, the hardware man, in his shop just a hundred feet away, imploring him to run and find out what had happened. He called Seigfried and not the police because he knew his number, and trying to contact the Highlands cops could waste precious time.

KILLER LEAVES A CALLING CARD

Meanwhile, lobstermen John Strasser, proprietor of the White Lobster Co., and Irving Parker, his employee, were pulling their boats up on the beach for winter storage just in front of the workshop. A man they knew to be Alexander Schreiber, Meisterknecht's brother-in-law, accosted them and handed Parker a scrap of paper on which was written, "Alexander Schreiber, Everton Ave., Cleveland, Ohio," saying, "It might be necessary to call the police soon, and if they want me I can be found at this address." He then went around the building and almost at once the fishermen heard five shots fired in rapid succession. Without hesitation, the Highlands men

ran around the building and saw Schreiber jump into a Buick sedan with another man driving. They only caught the first letter on the license plate, the letter *e*, indicating the car was registered in Essex County, New Jersey.

CURIOUS BACKGROUNDS OF SCHREIBER AND MEISTERKNECHT

Alexander Schreiber had been down at the workshop Monday morning looking for Meisterknecht, who was at the dentist's office. He said that Meisterknecht was twice married and had married his sister even though he had not gotten a divorce from his first wife, Parker told Highlands police officer James Bunner. A neighbor said the man had been in Highlands the previous Saturday, when the Meisterknechts were away, and that he said he would return on Sunday. They repeated their statements to Monmouth County Chief of Detectives John M. Smith, who brought Detectives Sacco and Musto, along with fingerprint expert Kent. The detectives learned that Schreiber was thought to be mentally deficient and a religious fanatic. He had been in the Highlands about a year before, when he caused a family crisis by claiming that Meisterknecht was a bigamist and had never divorced his first wife. Another time, he told Sophie that their poor old mother was at the point of death and asking for her. When she arrived in Cleveland, she found her mother glad to see her but in perfect health. Mrs. Meisterknecht told authorities that her brother came to see her at about twelve thirty on Monday and pleaded with her to leave her so-called husband and go with him to Cleveland, which she refused to do.

COURT ACTION IN HIGHLANDS

Highlands recorder William Meade issued a warrant for the arrest of Alexander Schreiber, charging him with murder. He held Olde, Strasser and Parker under $500 bail, each as a material witness. The so-called widow, Sophie Meisterknecht, was held under $10,000 bail as a material witness, as well.

AUTOPSY REPORT

County physician Harvey Hartman drove the twelve miles from his office in Keyport to Posten's funeral parlor in Atlantic Highlands in a little less

The main entrance and office of Fair View Cemetery, where the funeral fireworks went off over the burial of Meisterknecht's remains. *Author's collection.*

than twenty minutes the afternoon of the murder. His autopsy determined that the pistol that killed Meisterknecht was a .38-caliber special revolver, fired from about eight feet from the victim. All five bullets were extracted from the body. Two of them first entered the victim's right arm, one at the wrist and the other just under the shoulder joint, exiting in the armpit. This indicated that the gunman began firing at Meisterknecht as he turned from the desk and telephone. The next three bullets struck him in the chest. Two bullets entered the right side of the chest. The fatal shot, bringing instant death, struck directly in the heart.

Funeral Arrangements Were Made

After the Monmouth County coroner conducted his examination and inquest, the body of Herbert Meisterknecht was released to the funeral parlors of A.M. Posten and Sons in Atlantic Highlands for preparation. Mrs. Meisterknecht arranged to have the funeral Wednesday afternoon from her home at 85 Navesink Avenue, conducted by Reverend Howard

Frazer of the Episcopal Church of St. Andrew the Apostle, Bay Avenue, with the burial in Fair View Cemetery.

A Funeral with Floral Tributes, Fainting and Legal Fireworks

A few minutes after Reverend Frazer arrived to begin services at the house, a car pulled up on Navesink Avenue carrying attorney Charles R. Snyder of Atlantic Highlands and two women, Mrs. Susan Meisterknecht and her daughter, Martha, from Yonkers, New York.

The first Mrs. Meisterknecht remained outside. The second Mrs. Meisterknecht remained inside. There was going to be a standoff, legal and perhaps physical, as well.

Snyder asked Harry W. Posten to come outside, where he handed him the following document, upon which action the first Mrs. Meisterknecht became dizzy and fainted into the arms of Posten and Snyder.

> *You are hereby notified that I am the lawful widow of Herbert O. Meisterknecht, and as such demand the body of my husband and hereby notify you, your associates, servants and employees, not to interfere with my possession and custody of the corpse and the right of burial. SUSAN MEISTERKNECHT.*

After Mrs. Meisterknecht recovered, Posten went inside and spoke with Peter Olde, the lawyer and business associate of the slain man. Olde told him to ignore it since it was not a court order. Posten and Frazer nervously went on with the funeral service. As the body was about to be removed into the hearse, Posten was confronted by Highlands policemen Harry Rubley and Kyril Parker, who ordered that he was not to move the body until an agreement had been reached between attorneys Olde and Snyder. They agreed, in the interest of civility, to place the casket temporarily in the receiving vault at the cemetery. Posten signed a document specifying this. Further, Olde led Mrs. Sophie Meisterknecht out a rear door and to her car, while Snyder led Mrs. Susan Meisterknecht and Martha, fourteen years old, through the front door to view the body.

The casket holding the body of Herbert O. Meisterknecht draped in the American flag—the deceased had served in the World War as a lieutenant commander aboard a torpedo boat—was loaded into the hearse by bearers headed up by Frank Seigfried. The funeral cortege was made up of eight

cars, including two with nine reporters and photographers and another with three detectives on the watch for the second Mrs. Meisterknecht's brother, in case he should appear at the cemetery.

Another rather emotionally supercharged scene took place in Fair View Cemetery as the two widows ridiculed each other's grief. Wife Susan and wife Sophie boldly stood their ground, one on each side of the casket as it was being placed into the receiving vault. Disparaging insults were flung and dagger glances were hurled between the two women until the vault was closed and the funeral was concluded.

At a conference held on Monday following the funeral, Mr. Snyder, representing Mrs. Susan Meisterknecht, and William E. Foster, representing Mrs. Sophie Meisterknecht, agreed to give the former possession of the body. Afterward, attorney Snyder told reporters that, indeed, Mrs. Susan Meisterknecht was the legal wife, now widow, of the murdered man, that no divorce had ever been granted or even sought, that Mrs. Sophie Schreiber Meisterknecht and Mr. Meisterknecht had been illegally married two years before in Cleveland, Ohio, and that Mr. Meisterknecht had asked his first wife to sign a paper stating that she had only been his housekeeper and she refused. Mr. Snyder spoke of how poor Mrs. Susan Meisterknecht had suffered through this whole terrible affair, the horror of the murder, the shock of discovering she had been illegally replaced by another woman, all compounded by the tragic loss of her only son, Herbert Jr., a mere eighteen years old, who had died in September while camping in New York State. He said that the poor woman was distressed and did not know what would become of her and her daughter.

THE CASE GROWS COLD

Despite the best efforts of the local Highlands police, who continually kept watch for Schreiber's return, and of the county detectives and the state police, working with the Cleveland police, it appeared that all trace of the suspected killer was lost. Gradually, other, more pressing, matters weighed heavily on the law enforcement agents: rampant gangster violence and murders fed by bootlegging and, most recently, drug trafficking. The Meisterknecht murder was all but forgotten.

Furman Parker, shown here in the early 1930s, offloads his harvest of hard clams near one of the clam processing sheds along the river in the Parkertown section of Highlands. *Author's collection.*

A LUCKY BREAK REOPENS THE CASE

Then, out of the blue, in January 1934 the Highlands cops got a phone call from the county detectives and New Jersey state police. They had arrested a man named George Schreiber in Pennsauken on a statutory charge, and they suspected he was the same as Alexander Schreiber, wanted for murder the last six years. The county prosecutor needed identification and requested that Irving Parker go with Highlands Officer Howard Monahan to Pennsauken to identify the suspect. Unfortunately, Parker could not make a positive identification—after six years—and could only say that the suspect seemed to be Alexander Schreiber, only a bit lighter, but he could not be sure. The police tried to match the fingerprints of the arrested man to those of the alleged killer; however, they were unable to find any record of his prints on file.

So, the case of the murder of Herbert O. Meisterknecht remains to this day open, but in the *very* cold case files of the Monmouth County prosecutor's office in Freehold.

CROOK COPS BEAT OUT A CONFESSION FOR RAYMOND WADDELL'S MURDER

January 5, 1931

Raymond Waddell, of Highlands, died on the Shrewsbury River near Barley Point Island, the night of Jan. 5, 1931, while with John Bailey and Lewis Parker, both of Highlands. When the body was found months later, the coroner's postmortem showed death to have been a homicide.

What began as a group of friends having a few rounds of drinks—illegal during Prohibition days—ended in a drunken brawl on a deserted island, homicide and poorly told lies to cover it up.

Louis Parker, John Bailey, Charles Hartsgrove, Ray Waddell and Roxy Fiola started drinking early on the day of the murder, January 5, 1931. The first three were clammers, and they didn't go out on the water that day to rake in some clam money, as much as they and their families needed it, due to the bitter cold and rough water. A big blow was approaching, and they were all better off staying at Roxy's Hotel along the river in Water Witch. Ray Waddell now worked for Roxy and had lived there since coming up from Kentucky to work on the crews wrecking the old steamship, *Victoria*, sunk and blocking the Sandy Hook channel. Roxy would not allow them in the hotel, and, anyway, they were content to play some cards and drink some hot clam broth and some cheap so-called whiskey to keep up their spirits and ward off the cold in Roxy's old clam shack. Arguments over various things arose from time to time, but nothing so serious that a few more drinks couldn't soothe.

Once in a while, Roxy or Charlie Hartsgrove would leave, and another Highlander would pop in, Earl Smith, Tom Matthews or old Harry Oakes, seventy-three, who gave the two clammers a check for twenty-seven dollars

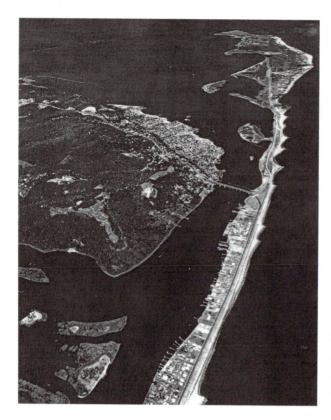

Barley Point Island, where Waddell was murdered, is one of the large islands in the lower left, just a short distance by boat from Roxy's in Highlands at the top. *Author's collection.*

to go and bring him five gallons of alcohol, allowing them to keep a quart for their trouble. Oakes was visited by two of them again that night, late, when he was told that Ray Waddell was dead.

All these details and a lot more information would come out much later in the trial of Parker and Bailey for the murder of their drinking friend, Ray Waddell.

How the Accident Happened

Parker and Bailey swore to Recorder Jere Carew of the borough of Rumson that they were telling the truth late on the night of January 5. Justice Carew noted that they were both drunk, as he would later testify in court during their trial. They had voluntarily come to report that their good friend Ray Waddell had accidentally fallen overboard and drowned in the river. They said that the three of them were headed out, despite the storm, in Waddell's motorboat, making for Abram Parker's, Louis Parker's father's shack on

Crook Cops Beat Out a Confession

Edelsohn's Island. (This island is variously named Edelsohn's, Barley Point or River Island.) They said that Waddell stood up and was blown out of the boat by a big gust of wind. Neither knew if Waddell could swim. By the time they circled the boat back, there was no sign of their friend. They figured he was drowned and dead, and they best report the accident.

Judge Carew had lots of experience in questioning people in his court and knew it best to ask questions and take statements from people separately. He noted serious conflicts between the two men's testimony (Bailey said Waddell had been pushed overboard while Parker said he had fallen out of the boat) and concluded that a further investigation by the county detectives was warranted. Carew then held both Parker and Bailey in separate cells at the Rumson police headquarters, without bail, as material witnesses.

A Parallel Case Is Opened

The next day, Tuesday, the Monmouth County detectives took charge of the case. Officers William Musto and Amerigo Sacco, under the direction of Chief of Detectives Harry B. Crook, took Parker and Bailey into custody. While they were being interrogated, Parker foolishly let slip something that led the detectives to begin a parallel investigation, one regarding a recent rash of break-ins in Highlands. Further grilling by Crook's men gave enough grounds for the arrest of Louis Parker, John Bailey, Charles Hartsgrove and Roxy Fiola on charges of breaking into vacant summer bungalows and cottages, stealing plumbing, electrical fixtures and home furnishings and selling or pawning them for cash. A search of Fiola's hotel resulted in him being additionally charged with receiving and storing stolen goods. All four were taken and arraigned before Highlands Recorder George W. Hardy, who held Fiola under $1,000 bail and the other three without bail, pending outcome of the grand jury.

The Murder Investigation Continues

Detective Crook got the cooperation of the Sandy Hook Coast Guard, and all day Tuesday they dragged the river in the vicinity described by Parker and Bailey. Nothing came of it. The Highlands fishermen familiar with the Shrewsbury advised the detectives and press reporters that, because the current in that part of the river was very strong and due to the power of the storm the night before, Waddell's body could eventually turn up some

good distance away. They also advised that the river might keep the body hidden for several weeks before it would release it to rise to the surface. They knew this from their past experiences living and working on the river. Crook advised the county prosecutor that they would continue working on getting information from Parker and Bailey, perhaps even a confession, or maybe an admission of one against the other. The two had been released on bail. The county could not hold them any longer without bail on the Waddell charge or the bungalow burglary charge. Crook knew the river would eventually give up Waddell's body. There was no rushing it; they just had to be patient and wait.

THE BODY RISES TO THE SURFACE

Almost three full months after the death of Raymond Waddell, the Shrewsbury gave up its corpse. Thomas Matthews (a descendant of Davie Matthews from the Cudjo case), age fifty-four of Highlands, was out on the river clamming when he heard a city man in a boat calling for help, yelling that he had hooked onto a dead body. Matthews took the body in tow and motored back to Highlands. Word spread fast, the cops were there and everybody was talking how Ray Waddell had been found after all that time. The date was March 30, 1931.

Harry Posten had the unenviable job of taking the body out of the water and getting it back to his funeral parlor in Atlantic Highlands. The Monmouth County physician was already on his way. Dr. Harvey W. Hartman did his autopsy at Posten's and phoned the results in to Chief Harry Crook in Freehold. Hartman reported that Waddell had a fractured skull and a broken jaw. He found no evidence of water in the lungs. His professional opinion was that Waddell was dead before he entered the water. He had likely received two blows with some blunt instrument and the blow to the head had killed him.

Harry Crook almost gleefully told Musto and Sacco that they now had a murder case—either Parker or Bailey, or both, was the murderer. He told them to go to the Highlands, arrest the suspects and see what they could get out of them now, putting a squeeze on them a bit.

Harry Posten prepared the body for shipment. Months before, Ray Waddell's father had provided telegraphed instructions outlining where and how to ship his son's body when it was found. Mr. E.J. Waddell was certain it would be found. He trusted the Monmouth County detectives. Mr. Waddell was a cop himself, assistant chief of police of Bowling Green, Kentucky.

Crook Cops Beat Out a Confession

Harry Crook telephoned Mr. Waddell to tell him the news, feeling he had an obligation to a fellow policeman and knowing that the county would pay him for the call.

County Men Get Results

Crook's men, assisted by state troopers who were experienced in such matters, grilled Louis Parker for twelve straight hours. They made it clear that they had proof he had been lying about how Ray Waddell had died. They made him read the autopsy report out loud, hesitating due to fatigue and struggling over the big words. The interrogators let him know that Bailey would soon crack and tell all, so he had better come clean fast with all he knew. The state cops alternated with the county men in pressing Parker, one team leaving the other with the man they all knew was guilty, alone or with Bailey, of killing Waddell.

Finally, Parker cracked. He told them it was John Bailey who killed Waddell right in the motorboat and threw him overboard. Bailey, confronted with the accusation lodged by his friend, denied the charge and insisted Waddell had fallen out of the boat, just as they had said from the beginning.

Roxy Fiola continued in business in the Water Witch section of Highlands, as seen in this postcard from the 1950s. *Author's collection.*

Crook was frustrated. After all those hours, this was all the suspects gave up. It would never hold up in court. His men had to do better, and he sent them back to really get Parker to talk. Not much time later, Musto and Sacco told Crook they needed a stenographer because Parker had confessed. They had it all now, iron clad. The prosecutor figured they would go to trial in July, an open-and-shut case for sure.

PARKER ON TRIAL FIRST

The trial of the *State of New Jersey v. Louis Parker*, charged with second-degree murder of Raymond Waddell on January 5, 1931, was before Judge Truax in Freehold. After the usual jury selection and empanelling, which was conducted with only minor problems, the state's case was presented by Monmouth County Assistant Prosecutor McDermott. His shortlist of witnesses essentially established the circumstances of the fatal boat trip, the finding of Waddell's body and the medical examiner's report. The real highlight of three days in court came when Assistant Prosecutor Victor Carton was called to read into the court record the confession of Louis Parker.

> *Waddell and Bailey got into a dispute in the boat about a round of drinks at Roxy's before we had started out. I got them to sit back down and be quiet. But as soon as we got to Shamrock Island, they started their arguing all over again. I tried to separate them and Waddell made a pass at me and called me vile names. I ran back to the boat and took a piece of ¾ inch galvanized iron pipe about three foot long and ran back with it. Bailey was punching Waddell and I said, "If you two guys don't quit f---ing." Well, Waddell got the blow on the head when I swung the f---ing pipe. He fell to the ground. Blood was coming out his mouth. I said to Bailey, "Is he all right?" Bailey said, "No, I guess he's killed." I said, "Well what are we going to do about it." And he said he didn't know what to do. Then we decided to load Waddell into the boat and dump him in the river and go back to Roxy's and tell him Waddell drowned. And Bailey said, "No, we are going to go to the nearest police station and make a report there." I took Waddell by the shoulders and Bailey by the feet and loaded him into the boat and dumped him in the channel. We went to Heller's island where my father lives and told him Waddell had drowned and on his advice we went to the police.*

Crook Cops Beat Out a Confession

The courtroom was dead silent from start to finish. Low sighs could be heard coming from the spectators sitting behind the two defendants. Defense attorney Joseph Mattice objected to the validity of the confession but was overruled.

Once the state rested, Mattice began the defense, stating that he would prove that the so-called confession was invalid—Parker had been severely beaten by state troopers and county detectives to extract his statement, which he maintained was coerced and never given voluntarily. He called several witnesses to testify that both Parker and Bailey were very intoxicated before and after the boat trip. He called Musto and Sacco and attempted to get them to incriminate themselves and admit, or imply, that they had beaten Parker unmercifully during the long period of interrogation he had to endure. The county men did not budge, maintaining that Parker freely confessed.

The Jury Deliberates Three Hours

Judge Truax instructed the jury members on the law, informing them they could find Parker guilty of first- or second-degree murder or manslaughter and that they should consider whether Parker had been beaten to give the confession. He sent them off to deliberate at 10:45 a.m. on Tuesday, July 14, 1931. They were back in their seats by 1:45 p.m. Truax received and read their decision and had the bailiff return it to the jury foreman, Mrs. Clara Blodis. He had Parker stand and admonished the people in his courtroom to refrain from outbursts. Then he asked the foreman the usual question.

"…We have, your Honor. We find the defendant, Louis Parker, not guilty."

Parker was set free immediately. Assistant Prosecutor McDermott entered *nolle prosequi* (to not wish to prosecute) on the charges against John Bailey, telling the judge that the state had no other evidence against him.

THE KILLER LEFT A KING OF SPADES AT AL LILLIEN'S MURDER

March 23, 1933

Alexander Lillien, age 36, was gunned down and killed sometime on Mar. 23, 1933 by an unknown assailant in the old Oscar Hammerstein mansion overlooking Atlantic Highlands.

New York Times
Mar. 25, 1933

SPADE KING CLUE IN LILLIEN SLAYING
Upturned Card and Pallbearers' Gloves
Found Near Body in Jersey House

REPRISAL HINT IS SEEN
Police Theories Link Killing of Rum-Ring Leader to Other Deaths
Two Are Held
Special to the New York Times

ATLANTIC HIGHLANDS, N.J. Mar. 24—A pair of pallbearer's gloves and an upturned king of spades offered the only clues tonight to the murder of Alexander (Al) Lillien, the 36 year old "master mind" of the New Jersey coast rumrunners.

Lillien's body, with three bullets in the head—one of them a distinct contact wound at the back of the neck—was found at 8 o'clock last night on the top floor of the old, green shingled Oscar Hammerstein mansion on the bluff overlooking the bay that was the ring's headquarters in 1929.

The Killer Left a King of Spades at Al Lillien's Murder

Harry B. Crook, chief of Monmouth County detectives, and Federal operatives spent the day questioning William Feeney, and Walter Gerleit, two of Lillien's associates, who discovered the body in the darkened mansion after they had returned from a "business trip" to Manasquan, upon which Lillien sent them.

Gerleit and Feeney told the police that they had no idea who might have done the shooting. It was they who found the gloves and the card on the floor. Both were held in $5,000 bail each this afternoon by Common Pleas Judge Truax, as material witnesses, pending action by the Grand Jury.

It was suggested here that the king of spades left by the slayers might be a hint that Lillien's death could be linked to the murder in Boston two months ago of Charles (King) Solomon, who was one of Lillien's business associates.

Another theory is that the killing might be traced to the scattered remainder of the rum-running outfit controlled by the late Charles (Vannie) Higgins, whose outfit had frequent brushes with the Lillien organization. It was common legend that Lillien and Higgins took turns at giving Federal officials advance information about each other's cargo landings.

Higgins was shot to death in Brooklyn last June.

Lillien was buried today in Oheb Sholem Cemetery in Hillside, near Newark. He leaves a wife, Mrs. Beatrice Cohen Lillien, a brother, William and his parents, Mr. And Mrs. Alexander Lillien of Elizabeth.

"STORMY WEATHER SINCE MY BUFF AND I AIN'T TOGETHER"

James Marson's Murder, August 23, 1933

One of the most sensational murders to take place in the Highlands since the Donnelly murder case in the Sea View Hotel almost a century before, the Franklin murder in Jenkinson's Pavilion fifty years before and the murder of Charles Stratton in Dorsett's Hotel some twenty-five years before was the killing of "Buff" Marson in a hotel notorious for shady dealings during the summer of 1933 and long before. People began to think that staying in Highlands hotels was detrimental to their health.

Things that made the case so outstanding were the suspected involvement of organized crime, the mishandling of the investigation by Monmouth County detectives, the professionalism of the Highlands police force and their testimony in the charges later filed against Harry B. Crook, chief of county detectives.

> *James "Buff" Marson was gunned down and killed in the early hours of Friday, Aug. 23, 1933, by unknown assailants, in the Albion Hotel in Highlands, N.J.*

Marson was seated at a table in the barroom of the Albion Hotel on South Bay Avenue at about 4:00 a.m. on Friday, August 23, 1933. He had been playing cards. Someone shot him in the back four times from close range. He died en route to the Monmouth Memorial Hospital in Long Branch, having been taken there by the Highlands first aid squad's ambulance.

"Stormy Weather Since My Buff and I Ain't Together"

The Albion Hotel, formerly the Tuxedo Hotel, is shown at the far right in this 1910 postcard. The market mentioned in the trial is the small building to the left of the hotel. Note the two-level houseboat tied up at the left. The porch that policeman Kyril Parker climbed onto in order to enter the singer's bedroom is seen at the side of the main building. *Author's collection.*

THE INVESTIGATION

The first official to arrive on the crime scene was Borough Recorder (i.e., Justice of the Peace) Matt Horan, who happened to be nearby, up on the Route 36 end of Portland Road, watching out after complaints of petty theft. At least that was the reason given; more likely, he had been watching the comings and goings at the Albion. Next, policeman Kyril Parker arrived. Both reported that Marson, under the table with his legs crossed and drawn up, was moaning and attempting to speak, perhaps trying to say who had shot him, but he was unable to articulate his thoughts, having quickly lost consciousness. Policeman Howard Monahan, now on the scene, and Parker held three employees of the hotel present at the time of the crime as material witnesses, but they refused to admit to having heard any shots. They were Salvatore Burgunzi, alias Tommy Doyle, the bartender and manager working for the owner, Harold Lindauer; his brother Peter Burgunzi, a porter; and Jean LeRoy, a sexy twenty-three-year-old blond torch singer from New York City.

Matt Horan knew it would be best to interrogate and take statements from these people and not wait for the Monmouth County detectives to arrive. It was strange that there were no hotel guests, just the three workers.

Strange, too, that none of them knew anything, heard anything or saw anything. Sal Burgunzi, age forty-two, claimed he had gone outside for a walk to get some fresh air and a smoke by the brand-new bridge and was "mooching" (taking some fruit or food without paying) down the sidewalk at the market to the rear of the hotel when he saw a number of persons running toward the hotel. His thirty-eight-year-old brother, Pete Burgunzi, said he was awakened by the shots. He put on shoes and trousers and went downstairs, passing through the barroom to a lavatory without seeing the body of Marson on the floor, although it was almost directly in his path. It was not until after he came from the lavatory that he said he saw the body.

Jean LeRoy stated she heard nothing whatsoever since she had had too much to drink and went to bed (in a room directly above the barroom) early and fairly well passed out. The police could verify her story: Monahan pounded loudly on her hotel room door without result. Kyril Parker had to climb a porch pole to get onto a roof and into her room through a window. After letting Monahan in, they both shook her to wake her up. Horan ordered the police to arrest and hold the three as material witnesses. He held Salvatore Burgunzi on $5,000 bail, and Peter Burgunzi and Jean LeRoy on $1,000 each.

The Other "Investigation"

When the Monmouth County detectives, headed up by Chief Harry B. Crook, arrived, the crime scene had been secured through the efforts of the two Highlands policemen, assisted by Recorder Matt Horan and Mayor George W. Hardy. Immediately, Crook ordered all three material witnesses released without first having interrogated them. Horan refused and had the three taken to the Highlands lockup, where later in the morning Lindauer, the hotel proprietor, posted their bails. Crook and his detectives, Mustoe, Sacco and Zuckermann, searched all the rooms of the hotel, while the Highlands officials remained in the barroom. (In a hearing two years later, it was suggested that the county cops were helping themselves to whatever valuables they may have found.) The county men did not even cursorily search the barroom where the murder took place.

When Crook and his men finally entered the murder room, Kyril Parker called his attention to a deck of cards on the shiny-topped playing table and a score sheet with the initials "B" and "J." He suggested that "B" was James "Buff" Marson and that perhaps the "J" was the name of the person who killed him or witnessed the killing. He reminded Crook that "J" could

have been Jean LeRoy, the singer, or another person. Parker also pointed out that fingerprints were clearly evident on the cards, the score sheet and the tabletop, even without forensic enhancement. The reaction of the detectives was total disinterest. The cards and sheet were carefully removed and preserved in police headquarters after the county men left.

Kyril Parker also noted to Crook that as he arrived at the hotel, another man named John Calandriello of Fair Haven was right behind him. Calandriello refused to stay for questioning and left (only to be picked up as a material witness some ten days later). He made a curious, somewhat incriminating statement, and John Calandriello might have been the "J" on the sheet, but this was not important to Crook and the county detectives.

Officer Monahan had traced a telephone call to the hotel on the day of the murder from a person asking to speak to "Buff." The call originated from Calandriello's home in Fair Haven. This, too, was dismissed by the Monmouth County "investigators."

AUTOPSY REPORT

Examination by Dr. Harvey W. Hartman, county physician, and Dr. Daniel Featherston, of Asbury Park, disclosed that all four bullets had lodged in Marson's back and had apparently been fired from behind. One had been flattened against a rib; another had penetrated nearly through the body. A third had entered the body after puncturing Marson's right arm, and the fourth had slanted downward into the abdominal cavity. It was this bullet that caused an abdominal hemorrhage and death. The direction taken by the bullets indicated that the victim had been sitting with his face on his arm on the table when he was surprised by the killer. It was the Highlands police theory, not corroborated by the autopsy, that he had purposely been drugged or plied with liquor in order to make him an easy victim.

Atlantic Highlands Journal
Aug. 31, 1933
Famed Gangster Buried
James Marson's Last Dealings

What, according to precedent in gangland slayings, will be the final chapter in the murder of James "Buff" Marson in Highlands last Friday morning was written in Atlantic Highlands Monday where the funeral of

the murdered man was held from the chapel of the undertaking parlors of A.M. Posten and son. A brief service was conducted by the Rev. George R. Ellin, pastor of the Central Baptist church in the presence of relatives and friends of the alleged racketeer after which about a dozen automobiles followed the hearse to Fair View Cemetery where interment took place. There was a profusion of floral tributes. The chief mourners were Mrs. Dorothy Marson, widow of the dead man, and his brother Peter Marson, a New York City policeman. Mrs. Marson, a former Red Bank girl, was visiting friends in McKeesport, Pennsylvania, at the time of the killing and had arrived here last Saturday in response to a telegram from police informing her of her husband's fate.

SEVERAL THEORIES ON THE MOTIVE FOR MURDER

Throughout Highlands and the general area, it was the common opinion that the shooting would take its place among the many other racketeer murders and unsolved mysteries.

One theory, at first advanced, linked the killing to that of Dave Zipper, gangster leader in Newark, during the preceding week. (The gun that killed him was traced to a pistol sold by Kislin's Sporting Goods in Red Bank.) This was not seriously considered, as Marson did not exactly fit into that picture. Marson had lived in Highlands for nearly ten years, and while he was classified as being connected with the bootlegging ring in a minor capacity, he was not the sort to make enemies. As a matter of fact, those who knew him spoke highly of him.

A man with two women, one of whom was dressed in red, whom Burgunzi said he saw as he ran toward the hotel after the shooting were considered possible factors in the crime, but they were more likely to have been just late-night and early morning intoxicated celebrants.

More credence was given in Highlands that the shooting was the outbreak of transactions in narcotics. It had been known for some time that, as the imminent repeal of Prohibition put the brakes on the rumrunning game, many of the gangsters who had been engaged in liquor smuggling were turning to narcotics as a substitute. Rumors had been current that a considerable amount of opium and its derivatives was being smuggled into the country through the Sandy Hook Bay route. It had been intimated that some information in regard to this traffic had reached the federal authorities.

The Albion Hotel, in which the killing took place, had previously figured in the news in connection with bootlegging investigations. It was here that

Prohibition agents, two years earlier, raided a powerful radio installation that was alleged to have been used to communicate with rum craft at sea. A searchlight also was discovered and was believed to have been part of the same hookup. The resort had long been known to be a hangout of the rumrunning fraternity and was said to have served a similar purpose for the dope smugglers. Police said that the "hopheads," who were arrested in Atlantic Highlands some weeks before on pickpocket charges, had made their headquarters at the hotel. Two of these men had served time in the Atlanta penitentiary on narcotics convictions.

Rumors circulated at the time of the murder that there were circumstances of the crime that had not been made public. It was said that Marson, who for a number of years had been known as a small-time bootlegger, had assumed that character to cover up his activities as a federal operative. A prominent Monmouth County bootlegger had recognized Marson as a former police officer who had entered the government service and the killing had followed immediately.

Through the efforts of *Asbury Park Press* reporter Alfred Jervis, John and Thomas Calandriello became suspects as well. Marson was believed to have argued with John Calandriello, a well-known county rumrunner, over the territory he was supplying with illicit liquor. Another source claimed that Marson and Thomas Calandriello had played a card game in Atlantic Highlands days before, Calandriello lost $100 and refused to pay up and Marson severely beat him. It was supposed that the $100 in ten $10 bills—the only money found on Marson—was the amount repaid by John Calandriello, whose son may have killed him in revenge for the beating. A phone call to the Albion prior to the murder by a man asking for "Buff" was traced to Calandriello's house in Fair Haven. The "J" on the score sheet, along with a "B" for "Buff," may well have been for John Calandriello. When he arrived at the Albion just after officer Kyril Parker, his first words—"How is Buff?"—suggested that he knew Marson had been shot. John Calandriello skipped out of the hotel, despite having been ordered by authorities to remain for questioning, and when Chief Crook finally did want to question both him and Thomas, they were nowhere to be found for over a week.

COUNTY PROSECUTOR IS PRESSURED FOR RESULTS

Monmouth County Prosecutor Jonas Tumen was feeling intense pressure to bring the killer to justice. In the Highlands, Mayor Fred Bedle was

threatening to travel to Trenton and demand the appointment of a special prosecutor in the Marson case, which appeared to be going nowhere due to prosecutorial lack of initiative and county detective Crook's incompetence or dereliction of duty. In Trenton, Governor Moore was issuing public letters to key municipalities demanding that all forces wage a war on crime and bring the criminals to swift justice.

Tumen had to seem to be accomplishing something. Soon after the murder, he named Salvatore "Tommy Doyle" Burgunzi as the leading suspect in the killing. His $5,000 bail was revoked, and he was charged with the murder and locked up in the Freehold jail, pending the outcome of Chief Detective Harry Crook's ongoing investigation. When journalists questioned the status of the investigation, Crook stated he was following some other important leads and looking at other suspects, but he would not comment on these or on the status of Burgunzi.

Burgunzi had an extensive criminal record in New York dating back to his youth. His record in New Jersey was clean. He admitted to local and county police that he had been a drug addict but had not recently used drugs. He admitted that he was the last to see Marson alive—he had left the victim sitting at a table as he stepped outside for some air.

Red Bank Register
Aug. 30, 1933.
Governor Calls for War on Crime
Urges Redoubled Efforts to End
Terrorism by Gangsters and Racketeers

Governor A. Harry Moore has sent the following letter to Charles R. English, Mayor of Red Bank:

Kidnapping, murder, extortion under threat of violence and death, "strong-arm" crimes committed for a fixed price have become all too common in our midst. It is high time that every agency in government unite in aid of law enforcement.

The people in our state have a common enemy—the gangster, kidnapper, and murderer—and we must by concerted effort face this common enemy and exterminate him.

I need but refer to the murders and crimes of violence which have occurred in different counties of our state. These criminals have gone unpunished; these murders have gone unsolved. Something must be done. Public officials must be made to see their responsibility and every effort put forth to bring to justice not only the criminals but also public officials who

by their apparent indifference to their sworn duty, tolerate the harboring of this class of criminal and general contempt for the law.

I call upon the prosecutors of this state, with their forces of detectives, to work in unison with the police officials of municipalities. Crime cannot continue to exist for a single week if police are loyal and vigilant. The cabaret, the low night club and places of this character are the meeting places of criminals and places where they are harbored and hidden. These places must be stamped out and in the meanwhile kept under the strong searchlight of police vigilance.

There is no place in this state for any official who, cloaked with the authority to suppress the criminal element, shirks his responsibility.

In certain areas of the state, it is apparent that either the police are lax or the officials charged with directing law enforcement are indifferent and sometimes corrupt. No public official can close his eyes to the protection of gangster headquarters or rendezvous which harbor members of the underworld year after year and plead ignorance of their existence.

The magistrate too must be part of this warfare against gangdom. The accused must have a speedy and fair trial and a just finding.

Only through the united efforts of all parties will the war on crime be won.

HIGHLANDS BOOTLEGGER FOUND SLAIN IN HOTEL ONCE USED BY RUM RING

Mayor Urges Whipping Post As Cure For Jersey Crimes

Answers Communication From Governor . Suggestion That Criminal Code Be Amended.

Pledges Cooperation Here.

FOUR ARE QUESTIONED

James Marson Shot in Barroom of Albion—Unable to Name Killer.

FOUND BY BORO RECORDER

Question Manager Who Left "For a Walk."

Mayor C. E. F. Hetrick is in favor of the public whipping post as a cure for crime.

In answer to a communication from Gov. A. Harry Moore, in which the governor deplored the present crime situation in the state and appealed for a clean up of gangs and racketeers, Mayor Hetrick in a letter to the gov-

-uced to the minimum in the city of Asbury Park."

"Permit me," the mayor's letter continued, "to suggest that the legislature authorize modifications of the criminal practice code in New Jersey in order that quicker and more stringent punishment may be secured thru the criminal courts of our state to the end that Jersey justice may once again be a

(Staff Correspondent)
HIGHLANDS, Aug. 23.—Shot down by an unknown assailant as he sat sipping drinks in a waterfront barroom at 4.18 a. m. today, James Marson, 32, whom police said they believed had

The front-page article of the *Asbury Park Evening Press* of August 23, 1933, written by Alfred Jervis, may have caused criminal retaliation against the reporter, telephone threats and attempted murder as he drove home late one night from Highlands.

A Dangerous Sequel to Marson's Murder

A strange aftermath to the killing occurred the Wednesday morning after the Friday killing, when Alfred J. Jervis of Eatontown, a reporter who had been covering the crime for the *Asbury Park Press*, ran into the home of Chief of Police Zeigler in Little Silver in a highly excited and emotionally fragile condition and said that he had been shot at five times by some gunman. Examination of his automobile and the testimony of residents in the neighborhood convinced the Monmouth County detectives that Jervis had fired the shots himself while suffering a hallucination. His revolver was found to contain five empty cartridges, they asserted. Jervis was taken to the Hazard Hospital for observation. He was said by the city editor of the *Press* to have shown indications of mental upset and fatigue as a result of his aggressive work on the murder case.

It was Jervis who exposed the involvement of John Calandriello and his son, Thomas Calandriello, of Fair Haven, in the murder case. Both these men had been former members of the infamous Highlands rumrunning gang operating out of the Albion Hotel. They had been arrested during the massive bootlegging raid in October 1929 but failed to be convicted in the following trials. Jervis informed local police and his editor that threats on his life had been made by people said to be friends of the Calandriellos. The Highlands police advised him to be careful for his safety. Thereafter, Jervis armed himself with a .38-caliber revolver, which he legally carried as a special policeman in Eatontown, his hometown.

After talking to police and residents in Highlands the evening of August 29, 1933, at about midnight, Jervis was coming home late along Rumson Road, heading toward Little Silver. He was nervous and on edge, yet alert to any danger, for he knew the Calandriellos lived in Fair Haven near this route. The first sign of trouble was when he noticed that a sedan was following him; near the Rumson Country Club, it pulled out and sped past him. Then, as he drove through the Hance Avenue intersection, shots from a silencer-equipped pistol were fired at him from the same black, unlicensed sedan, which again appeared behind him and pulled out to his left. He returned the fire with five shots under the raised open windshield and scared off the attacker, who sped off down Rumson Road to the west.

Jervis raced his car to the home of Little Silver Police Chief Fred Ziegler, sounded his horn and gasped, "They opened fire on me. Get Kirkgard!" Ziegler phoned the Eatontown chief of police and then got Jervis to tell, as best he could given his serious emotional state, what had happened. Chief

"Stormy Weather Since My Buff and I Ain't Together"

Harry Kirkgard, Edward Emmons and first aid squad man and special policeman Andrew Becker came and took the reporter to the Hazard Hospital in Long Branch, where he was sedated and treated for mental breakdown for several days following.

County detective Harry B. Crook's findings differed significantly from those of Chiefs Kirkgard and Ziegler. Crook found no evidence of bullets striking the glass in Jervis's car from the outside, but only of glass blown out by shots fired from inside. He relied heavily on the fact that Jervis was being treated for nervousness by a physician and the estimate of his editor that he was under great emotional strain while on the story. Crook therefore concluded that the story was nothing but the wild ravings of an emotionally ill reporter suffering from delusions and trying to make a name for himself. However, Ziegler and Kirkgard found evidence to credit Jervis's story and saw the murder attempt to be in character with the criminal element of the day. Further, they found glass particles in Jervis's hair, which could only have come from glass shattered by shots from outside, and their inspection of the intersection showed skid marks in the gravel roadway consistent with Jervis's description. Everyone but Harry Crook considered Jervis a courageous and very fortunate young man.

CALANDRIELLOS IN CUSTODY

Al Jervis must have felt gratified after he was told that John and Thomas Calandriello had surrendered to Recorder Matt Horan in Highlands on Thursday afternoon, August 31, primarily because of his news articles. They surrendered voluntarily and appeared with their lawyer, Ward Kremer of Asbury Park, who also represented Sal Burgunzi and the whole Albion Hotel group, having been retained by Harold Lindauer. Kremer spoke on their behalf, stating that his two clients were appearing because they had heard they were wanted for questioning. Chief Crook was there and attempted to interrogate them, but Kremer refused to allow it. Justice Horan then held the two as material witnesses and set bail at $5,000 each, which Kremer paid, and they were released.

Both Calandriellos had been involved with the rumrunning gangs and frequently were cited as major players in that criminal activity. John Calandriello was one of the many arrested at the time of the infamous Highlands bootlegging ring at the Albion Hotel, the Villa Ritchie in Highlands and the Oscar Hammerstein mansion in the Hillside section overlooking Atlantic Highlands. During the big "dry agents" raid in late

October 1929, Calandriello was one of dozens arrested. Large amounts of liquor, weapons, cash, records and a powerful radio transmitter for communicating with rumrunning craft were confiscated.

BURGUNZI SET FOR TRIAL AS MARSON'S MURDERER

County Prosecutor Jonas Tumen announced the date of September 14, 1933, just thirteen days away, for the trial of Salvatore Burgunzi for the murder of James Marson. There were problems, however, with the case against Burgunzi. First, he had never been formally indicted on a charge of murder. A presentment to the Monmouth County grand jury had never even been made. A murder weapon had not yet been found, although the county authorities had been dragging the Shrewsbury River adjacent to the Albion Hotel for some days without result. The case against Burgunzi was weak and only circumstantial. He may have been in over his head as county prosecutor and kept relying on the detective team headed up by Harry Crook, who kept assuring him and the insistent press reporters that subpoenas were being requested for bringing other figures—unnamed, as usual—important to the case.

The trial date came and went, without a trial being held. On September 20, Ward Kremer, Burgunzi's attorney, notified County Prosecutor Tumen of his intention to seek a writ of habeas corpus before Supreme Court Justice Joseph B. Perskie in Trenton to have Burgunzi released from the county jail. He stated before the pressmen that Burgunzi had been held since August 25, and he was entitled either to be charged immediately and tried in court or, at the very least, released on bail to await further prosecutorial action. He emphasized that the only justification for holding Burgunzi was that he was the only one having actual knowledge of the circumstances under which James Marson was killed, no indictment had been found and there were no facts in the possession of the prosecutor upon which an indictment could fairly be grounded.

Kremer's request was denied by Justice Perskie, who made it clear that "Monmouth County shall take vigorous action to penetrate the mystery surrounding the crime and bring the guilty parties to justice." Perskie told Kremer that he might renew his application in the Supreme Court chambers in Atlantic City on November 4, when prosecutor Jonas Tumen would be given the opportunity to present the state's version of the crime.

"Stormy Weather Since My Buff and I Ain't Together"

After All, Marson Murder Remains a Mystery

The final result in the case of the murder of James "Buff" Marson was absolutely nothing. The state brought no action against any of the persons implicated in the killing. Jean LeRoy and Peter Burgunzi were released from bond. Salvatore Burgunzi was not indicted, not presented to a grand jury and was released from custody. John and Thomas Calandriello were also released from their bonds.

At the end of the whole pathetically handed affair, there in the Albion Hotel on South Bay Avenue, by the new bridge, business returned to normal. The same old patrons had returned for late-night parties and out-of-the-way rendezvous, and new ones came, too, quite titillated to be in the same barroom where "Buff" died, where it all had started. Not much had changed. The hot and sexy blond was still performing like a bombshell set to explode, paid well for her talent. Harold Lindauer, in a private back room, was there with Sal Burgunzi, John Calandriello and his son Tom, seated

The Highlands Police Department of 1946. Officers in the Marson and Crook cases were Howard Monahan, right, and Kyril Parker, second from right. *Author's collection.*

101

around a large green-clothed table. Cigar smoke filled the air and ashtrays were overflowing alongside dealt playing cards, all face up. Pete Burgunzi came in carrying a tray of drinks. Lindauer told him to leave the door open a second, so they could hear Jean LeRoy's sad song.

Don't know why
There's no sun up in the sky
Stormy weather
Since my Buff and I ain't together
Keeps raining all the time
Life is bare
Gloom and misery everywhere
Stormy weather
Just can't get my poor self together
I'm weary all the time
Every time
So weary all of the time
When Buff went away
The blues walked in and then they met me
If Buff stays away
That old rocking chair's bound to get me
All I do is pray
The Lord above will let me
Just walk in that sun again
Can't go on
Everything I had is gone
Stormy weather
Since my Buff and I ain't together
Keeps raining all the time
Keeps raining all the time.

"That's enough. Close that door, Pete."

Five glasses were raised, "Here's to Buff." It was repeated four times, "To Buff."

MARSON MURDER CASE IN THE HEADLINES AGAIN

The Marson murder case came up again in June and July of 1935, when the Highlands policemen, Kyril Parker and Howard Monahan, testified in the

"Stormy Weather Since My Buff and I Ain't Together"

Civil Service Commission action against Chief Detective Harry B. Crook, thereby helping to remove him from his position and vindicating the police department of the Borough of Highlands.

Over fifty-two allegations were laid out against Crook in the bill of particulars presented by the new Monmouth County prosecutor, Raymond T. Bazley, in Freehold. Some examples of his blatant corruption were: failure to dismantle an illegal still near Allentown and to arrest and bring charges against the operators; consorting in public with known criminals and gangsters and approval of gun permits to them; failure to secure evidence in the Marson murder case; making false official statements and submitting false accounts and receipts for repayment by the county; giving false testimony under oath in the Naughright probe; failure to cooperate with local and state police in criminal investigations; receiving gratuities and bribes to not prosecute criminal activities; receiving several expensive carpets as gifts from Alexander Lillien, a known criminal who was later murdered; taking and keeping stolen property recovered by investigations for his personal use for over two years; allowing his son to operate a speakeasy in Asbury Park, which he visited on numerous occasions; selling seized liquor in his son's speakeasy; taking and keeping money from seized slot machines, which he kept in his personal residence; and destruction of all his personal checks, receipts, stubs, records, record books and written communications to defeat the investigation of the Naughright probe against him.

After Crook's conviction and removal, he started a private investigation agency operating out of Freehold and Lakewood and, ultimately, an armored car business, resulting in Crook's competing with Brink's and Wells Fargo. One can only imagine amusing anecdotes such as "Don't Give your Money to Crook's!"

A Colored Man's Murder Goes Unsolved

William Nichols, April 6, 1934

William Nichols, a colored man of Navesink, Friday night Apr. 6, 1934, was likely murdered in his home which was subsequently set afire to mask the crime by a person or persons unknown.

Fire Ravaged Victim's Home

The place where Nichols lived alone is variously described as a house or shack in the "Negro settlement" on Mulberry Lane, a dirt path that leads off Monmouth Avenue, Navesink's main street. The building burned like dry kindling, and the Navesink and Leonardo fire companies had little chance to save it as it was just a mass of flames when the trucks arrived. Herbert Reed, a neighbor, attempted to save Nichols, whom he knew was inside. He tried courageously, again and again, to enter the place, but each time he was driven back by the intense flames.

Navesink Neighbors Tell Police of Their Suspicions

Some of Nichols's neighbors and those present at the time of the fire informed authorities of their suspicions that his skull must have been fractured before his body was dragged from the burned-out house. They reasoned that Nichols might have been killed before the fire and that the fire was set to cover up the murder. One main reason for this suspicion was the character of the house itself, which made it impossible to believe that

anyone aroused by the fire could not have been able to escape. The body had been found on the floor of the living room, where exit from the door or two windows would have been easily possible.

TALK OF A QUARREL

Some of the colored people said that on the evening of the fire Nichols was not alone in his home. He had been playing cards with at least two people. One was Charlie Locke, a well-known local character, in trouble with the law on various occasions. Another was Mrs. William Kearney, a Negro woman whose husband was serving a sentence in the state prison at Trenton for robbery and arson charges stemming from the fire at the residence of Arthur McKeever, at Plattmount in Atlantic Highlands, several years before.

AUTOPSY IS INCONCLUSIVE

Nichols's remains were taken immediately from the fire to Posten's undertaking rooms in Atlantic Highlands, and the next day an autopsy was performed by Monmouth County Physician Hartman. His report stated that no specific cause of death could be determined due to the extremely deteriorated state of the remains caused by the fire. It noted that it was not possible to determine whether there had been a skull fracture, given the degree of incineration of the skull.

INVESTIGATION GOES NO FURTHER

After nearly a week of investigation by Middletown Township police, supported by the Monmouth County detectives with the county prosecutor's office and the New Jersey State Police, no positive conclusions or leads to suspects had been made. The county authorities were especially interested in finding Locke, but his whereabouts had not been determined. Initially, the detectives were interested in Mrs. Kearney in so far as her husband was convicted of a similar crime (i.e., criminal theft and coverup arson), for which he was then doing time at Trenton prison. However, lack of certain evidence of murder or arson, and other information learned from local people, had slowed the investigation and had nearly brought it to a stop.

More Neighborhood Talk

With the case gone cold, people kept coming up with more opinions, especially in the colored communities in Navesink and in the Hillside section of Middletown above Atlantic Highlands. Many were convinced that the fire and resulting tragedy—if indeed there was no murder of Nichols—followed what they called a "canned heat" revel. This is a very strong beverage requiring a very hot fire to make it even partially potable. The drink itself, they say, is highly flammable, and perhaps some of it slopped over and caused the inferno. Then again, others figured that there had been a murder, which the killer successfully concealed by soaking the victim's head with the explosive liquor and igniting it.

Many good Christian Negros in these two areas resigned themselves to the fact that the truth about William Nichols's—a colored man's—death would never be discovered by the authorities and placed their trust in the Lord. Amen.

Background Information about Nichols

William Nichols, about sixty years old, had a reputation, aside from his habitually going on occasional drinking sprees, of being a good worker when sober. Formerly, he had been employed by the County Gas Company and the Central Railroad of New Jersey and for various local residents doing odd jobs. He was a gentle man and was fond of children. He liked to get a pocketful of pennies and distribute them amongst youngsters in the neighborhood. Nichols had no relatives as far as had been determined. His remains were interred in the colored Crystal Stream Cemetery without a grave marker.

THE BLIND JUDGE SEES JUSTICE IN MURIEL WALKER'S HOMICIDE

March 19, 1935

T his case occurred in the days long before the United States Supreme Court handed down its monumental ruling in the case *Roe v. Wade* on January 22, 1973, and, for the first time in America's history, legalized the right of a woman to choose to terminate her pregnancy through a medically approved abortion. In 1935 America, abortions were rare, but at times they were sought in out-of-state locations, with physicians willing to risk the legal and medical consequences of such illegal operations. At times, women resorted to "doctors," actually licensed or otherwise, who performed the necessary procedures in out-of-the-way hotels or even in a woman's home.

> *Muriel C. Walker, a local Highlands woman, died at the Hazard Hospital in Long Branch, Mar. 19, 1935, from complications following an illicit surgical procedure.*

THE DOCTOR CALLS

A man who identified himself as Dr. Hugh F. Quinn drove all the way from West New York, New Jersey, down to Highlands to the home of Mr. and Mrs. Curtis Walker, who shared it with Mrs. Walker's mother. It was a small, inexpensive place in the old Parkertown section that served the needs of the young couple and their twenty-month-old baby, named Curtis Jr. after his father, a Fort Hancock soldier. The small army pay, coming as it did once each month, was insufficient to meet all their basic needs. Muriel's mother,

John L. Opfermann, MD, was a highly qualified and respected Highlands physician. He served as postmaster (1913–18) and mayor (1925–26), and he always had a keen interest in helping Highlands improve its reputation. *Author's collection.*

Mrs. Nellie Conboy, helped as best she could afford, but her daughter felt trapped and overwhelmed, especially so once she found she had another mouth to feed soon on the way. Caring for Curtis Jr. was rough enough for the twenty-one-year-old mother. She and her husband together made the fateful decision to seek a way out. Muriel's mother was aware of it and perhaps reluctantly approved. She knew of two women who said they knew a doctor who would help. The doctor had been to town before, on more than one occasion, they assured her. "Just don't mention it to anyone, not anyone."

Dr. Quinn arrived early in the afternoon of February 26, 1935. The women who were there to help, Kate Foster and Theresa Major, let the doctor in. They had already prepared everything that would be needed for the operation. Quinn stayed just long enough to be sure all was well with his patient and not a moment longer. After dark, he received his pay and thanks and drove north. The two women had already received their pay, took care to clean up the operation's necessities and left. In the days following, Mrs. Conboy cared for her daughter and little Curtis. Muriel seemed to be doing well enough and perhaps gaining strength.

THE PATIENT'S CONDITION DETERIORATES

About the middle of March, just about two weeks after the operation, Muriel took a turn for the worse. Bleeding started and grew worse quickly. What Kate and Theresa did helped initially, but Mrs. Walker was clearly seriously ill. She was running a high fever. There were two doctors with offices in Highlands, both highly respected physicians whose primary concern was the health and well-being of their patients. Both were honest, ethical practitioners with high standards of conduct. Both had served a term as mayor of Highlands and respected the law. Dr. William Rowland was a Catholic, so Dr. John Opfermann was called Sunday, March 17. He examined the ill woman and immediately phoned Harry Rubley and Irving Parker at the first aid squad. They rushed Mrs. Walker down to the Hazard Hospital in Long Branch, a small private facility, more discrete than Monmouth Memorial Hospital.

The doctors and nurses at the hospital struggled to stabilize Mrs. Walker, yet her condition went steadily downhill due to loss of blood and infections. Curtis Walker and Mrs. Conboy were there at her side when Muriel Walker died, Tuesday, March 19, 1935.

Mrs. Nellie Conboy's modest, rented home on the second floor in the Parkertown section of Highlands, where "Doctor" Quinn made a house call to rid her daughter, Muriel Walker, of another mouth to feed. *Author's collection.*

DR. JOHN OPFERMANN CALLED AGAIN

Nellie Conboy's grief nearly overwhelmed her. She surely blamed herself and her son-in-law for all sorts of reasons. She blamed Dr. Quinn. The next day, she had doubts about this man. How could this happen? What kind of a doctor would...? She went to see Dr. Opfermann, for he would know what to do. The doctor made a few phone calls to the Hudson County Medical Society and the hospital nearest West New York. This confirmed what he had suspected since his first examination of the dangerously ill woman. Opfermann advised her to go and speak with Frank Hall, borough recorder or municipal judge.

THE BLIND JUDGE'S VERDICT

People called Recorder Frank Hall "the blind judge." He was indeed sightless, and that was due to an unfortunate accidental explosion during the early days of Prohibition, or so people hinted. No one openly spoke of it. The old rumrunning days were just part of the Highlands' better-not-mentioned history. Hall's honesty and integrity in enforcing the law were widely known, especially by accused men and women who stood before his bench. His verdicts and sentences were as fair and unbiased as the symbol of Justice herself, blindfolded and holding the scales of justice and the sword of punishment in her two hands. He had already spoken with John Opfermann on the telephone.

Frank Hall expressed his condolences to Mrs. Conboy for her loss. He listened patiently to her description of all the events leading up to Muriel's death. Her suspicions were his suspicions, as well.

The judge called William Mustoe over in Red Bank. He was the acting chief of the Monmouth County detective force. Harry Zuckerman, Amerigo Sacco and Merritt Kent, of the county prosecutor's office, were sent to West New York, where they arrested Hugh F. Quinn on Friday, March 22, 1935, and charged him with performing an illegal operation that caused the death of Mrs. Muriel C. Walker. Late the next day, they brought him before Recorder Frank Hall, who charged him officially and held him without bail. Quinn was taken to the secure lockup in the Red Bank jail at police headquarters on Monmouth Street, and the next day the detectives escorted him to the Monmouth County jail.

The Highlands police were part of the investigation, as well. Patrolmen Howard Johnson and Kyril Parker had found and arrested Kate Foster and

Theresa Major and brought them into Hall's court. The dead woman's husband was there, as well, in order to identify Quinn as the bogus doctor. Parker and Johnson had to restrain the young soldier, visibly affected by the death of his wife, who lost control of himself and lunged out at Quinn, shouting, "You killed my wife!"

Recorder Frank Hall restored order in his court and held the two women and Walker under bail as material witnesses.

SPECIAL AUTOPSY

The body of Mrs. Walker was taken immediately after her death to the Worden funeral home on Front Street in Red Bank, where it was kept pending further action. On Friday afternoon, after Quinn's arrest, an autopsy was performed there. Monmouth County Physician Harvey W. Hartman was assisted by Dr. Harrison S. Martland, chief medical examiner for Essex County and professor of forensic medicine at the Bellevue Hospital Medical College in New York. This was an extraordinary consultation, which reflected the desire on the part of fake-doctor Quinn's prosecutors to lay out an iron-clad case against Quinn for this and many other illegal operations.

A SAD AND LONELY FUNERAL

Later in the day, at 2:30 p.m., a private funeral service for family was conducted at the Worden funeral home. The next day, burial of Mrs. Muriel Conboy Walker's remains was quietly and discretely made in the Mount Olivet Cemetery, a Catholic burial ground in Middletown. Only her mother, her husband and one close girl friend from Leonardo High School attended.

"DOCTOR" QUINN BROUGHT TO JUSTICE?

The Monmouth County prosecutor sought and received from the grand jury an indictment of Quinn on the charge of performing an illegal operation, which caused the death of Muriel C. Walker, of Highlands. To this charge, Quinn pleaded not guilty. Again, the April 1935 grand jury brought forth an indictment of Quinn for the illegal practice of medicine. To this charge he

pleaded guilty—he had admitted to one of the county detectives that he was not a licensed physician—and was remanded for sentencing. Next, Judge Thomas H. Brown, sitting in Freehold, ruled that Quinn's pleading guilty to the second charge put him in double jeopardy should the first charge be prosecuted and consequently dismissed this first charge.

Hugh F. Quinn got off lightly with six years' prison time, more easily than he might have had the two charges been lodged in a single indictment and prosecution.

Shortly after this ruling, the public's attention was caught by the outrageously illegal behavior of a real doctor from Asbury Park.

Highlands Star
Mar. 12, 1936
Much Interest Still in Parks Case

More than ordinary interest is being taken tomorrow in the hearing in Asbury Park, in which Dr. William J. Parks, the Negro physician, who has evaded in one way or another a half dozen charges of illegal surgery. Once more he is accused of a similar crime...

Parks is already under a $50,000 bail pending trial on a charge of causing the death of Mrs. Holly Cantalice of Red Bank. As a result of this case his license to practice medicine was revoked last month by N.J. State Board of Medical Examiners...

Parks' difficulty with the law began as far back as 1921 when he was arrested following the death of Mrs. Hattie Stevens of Asbury Park. However, he was not convicted. About the same time he was tried for doing a similar operation upon a Newark woman and was convicted and sent to prison for one to seven years. The case was overturned on appeal by the N.J. Supreme Court.

EVIL ON NEIGHBORHOOD STREETS

Rosemary Calandriello's Murder, August 25, 1969

The predator moved slowly and secretly, prowling through the towns on the shore of Raritan Bay, stopping and watching, carefully observing possible prey, whenever it spotted young teenage girls, walking in twos or, better, alone. It moved like the monstrous, savage shark stalking its victim in the opening scenes of the movie *Jaws*, which cleared waters of swimmers all along the Jersey Shore during the intensely hot summer of its release in 1975. However, by contrast and in fairness to the fish, the shark was only following the dictates of the natural instincts of such creatures of the sea as it moved about, foraging for its food. Not so *this* predator, which, just two days before, found two twelve-year-old girls walking on Monmouth Avenue in Leonardo. It waited, then pulled up and, with pleasant smile and smooth words, it made its invitation to hop in, go for a ride and have a good time. Both refused the offer, stepped back and noted, as the car drove off, its description and license plate number. Later, at home, one of the girls told what had happened and gave her mother a slip of paper with the number on it.

On August 25, 1969, the predator returned and drove slowly about the streets, this time in Atlantic Highlands. It spotted her walking the half block toward a small store on Center Avenue. She was on her way with two dollars in her pocket for milk and ice cream. The predator stopped. The smile, the words, the invitation...not refused this time. The girl got into the car. The predator drove off. Fortunately, within minutes they were seen.

A bunch of boys, not really doing anything, just hanging out and driving around, were in Mike Hazeltine's '68 green Plymouth Fury. Tom Gowers was up front, the rest were in the back. They spotted the beat-up

The Calandriello family of five lived in this home at 93 Center Avenue, Atlantic Highlands, at the time of Rosemary's abduction and murder. It is actually just seven houses from the store where she would have gone for milk and ice cream. *Author's collection.*

Ford and it struck them as peculiar because they saw the shy and reserved Rosemary Calandriello, whom they knew from school—had no boyfriend, did not date—riding with a strange man. Hazeltine followed behind for a few blocks, but then everyone lost interest. They pulled away, not giving it another thought, at least till later that night. Hazeltine, Rosemary's down-the-street neighbor at 73 Center Avenue just to the left of the corner store, heard that the police were at Calandriello's house and heard why.

He went over there and told the cops what he and his friends had observed. The boys knew their cars and so he was able to give an accurate description of the beat-up Ford as he stood outside with the cops in front of the house. Good thing he did not go in. Mrs. Agnes Calandriello was beside herself with worry, practically out of her wits with recrimination. Why did she send Rosemary? It was all her fault. Where could she be? Not with neighbors, not with a girlfriend, not at church, not downtown on First Avenue—maybe in the movies? No, not without asking first. Did they check the two hospitals? Maybe she got sick or was in an accident? Such a good girl. The police tried to calm her down, to reassure her. But Sergeant Sam Guzzi, from his experience in law enforcement, did not have a good feeling about this case.

Evil on Neighborhood Streets

Rosemary Calandriello, 17-years-old, of Atlantic Highlands, N.J. was abducted off the street near her home, Aug. 25, 1969 and later murdered by Robert Zarinsky of Linden.

Guzzi realized the possible outcome. Still, he took all the required and usual steps in a thorough investigation, hoping for a breakthrough, and fast. He shook his head, a pessimistic movement, and drew in his lips between his teeth as he surveyed the details of the teletype alert he sent out to all area police departments.

THE ALARM IS SOUNDED

ATLANTIC HIGHLANDS, N.J.
26 AUGUST, 1969

MISSING PERSON REPORT

MISSING SINCE 25 AUGUST, 1969 AND BELIEVED ABDUCTED:

ROSEMARY CALANDRIELLO, OF 93 CENTER AVE., ATLANTIC HIGHLANDS, WHITE, FEMALE, AGE 17, 5'5" TALL, BROWN HAIR, POSSIBLE BRAIDS, BROWN EYES, OLIVE COMPLEXION, WEARING YELLOW AND LIGHT BLUE BLOUSE, YELLOW SHORTS, SANDALS, POSSIBLE WEARING EYE GLASSES.

LAST SEEN 6 P.M. IN 1961 WHITE FORD GALAXY CONVERTIBLE, WITH POSSIBLE BROKEN TAIL LIGHT AND DENTS IN REAR FENDER, RUST SPOTS ON EXTERIOR,

BEING DRIVEN BY WHITE MALE, SHORT, 5'3" TO 5'6" TALL, HUSKY, ROUND FACED, WITH PORK CHOP SIDEBURNS AND WELL TRIMMED GOATEE, WITH BIG HEAD OF DARK HAIR.

CONTACT: SGT. SAMUEL GUZZI, ATLANTIC HIGHLANDS P.D., 201-291-1212

Sergeant Sam Guzzi, Atlantic Highlands Police Department. *Author's collection.*

Police Have a Suspect

The local weekly newspaper, the *Courier*, carried a large and prominent article on Thursday: "Have You Seen This Girl?" The article and the talk it started made parents in the towns from Highlands to Keyport along the bay shore apprehensive about allowing their kids, especially their girls, to be far from home. There was real worry about a predator prowling for its prey on their streets. The mothers of the two twelve-year-olds from Leonardo went right to the police at town hall in Middletown and filed a complaint. They gave them the license plate number, a description of the car and its driver. Sergeant Guzzi and the Middletown police had just the break they needed. Quickly, the plate numbers were traced to a '61 white Ford Galaxy convertible registered to Robert Zarinsky of 402 Bower Street, Linden.

They moved fast, getting the necessary legal paperwork and getting up to Zarinsky's address. They moved fast, but not fast enough, for when they got there, Zarinsky had just finished washing the exterior and trunk of his car. The car was impounded and trucked to Hennessey's Auto Shop on Center Avenue, Atlantic Highlands. He was arrested in his home, placed in handcuffs and taken away by the police, who were verbally harassed by his mother and wife as they shouted curses and alibis for Zarinsky.

The next day, forensic analysts went over the car with the proverbial fine-toothed comb. They found hair clips and a pair of girl's panties—matching those in Rosemary's bureau drawer—but this information was not immediately released. An inquiring *Courier* reporter was told, off the record, that some hairs were also found and that all the evidence was being analyzed at the New Jersey State Police labs in Trenton.

PREDATOR BROUGHT TO TRIAL

Despite all this success, the police in both departments were frustrated that, without sufficient physical evidence to tie Zarinsky to Rosemary and the Leonardo girls, there was little they could charge him with, despite their absolute belief that he had abducted and killed Rosemary. Initially, Zarinsky was arrested and charged in Atlantic Highlands with contributing to the delinquency of a minor and released on $10,000 bail; in Middletown Township he was charged with interfering with the rights of others and released on $2,000 bail.

The two Leonardo girls were alive and at home with their parents thanks to a good lesson they had learned when on a class field trip to Middletown Police Headquarters. They were shown the headquarters and even the local jail cells. More important were the words of the juvenile officer on how to be alert and protect themselves from being accosted by strangers and how to observe, remember and record details important for the police.

FREED TO STRIKE AGAIN AND AGAIN

From then till mid-November, Zarinsky was free. The *Courier* of November 27, 1969, "Arrest Suspect in Missing Girl Case," related the details. Zarinsky was charged in Monmouth County court with attempted kidnapping of the two Leonardo girls and was indicted by the grand jury for attempting to entice the same two girls into his car. He was released on $50,000 bail.

Zarinsky was free. He was free, unleashed to resume his predatory ways and seek out and stalk new victims. Meanwhile, in court, Zarinsky was found not guilty of the Atlantic Highlands charge, and in the case lodged by Middletown, the judge essentially dismissed the charges, stating that, despite his personal opinion of Zarinsky's guilt, he found the state did not meet the burden of proof in prosecuting him.

Zarinsky was free and apparently did resume his wicked ways. He had the time, despite the claims to the contrary made by his wife. He worked

with his father, Julius Zarinsky, in the JZ Produce business, starting out at about 2:00 a.m. each day, loading up the refrigerated truck with fruits and vegetables and making deliveries to groceries and restaurants. By noon, Robert Zarinsky would just roam in his car for the rest of the day, never questioned by his terrorized-into-silence wife, sister and parents.

MORE MOTHERS WEEP

Before long, more victims started to show up. One young girl's body was found in the Raritan River, weighted down by heavy chains and with an electrical cord around her neck. This was Linda Balabanow of Union Township, killed the same year Rosemary disappeared. In December 1974, two teenage girls were also found, Joanne Delardo and Doreen Carlucci from Woodbridge, dead and with electrical cords about their necks also, dumped in an out-of-the-way part of Monmouth County.

DEDICATED COP AND PROSECUTOR SEE JUSTICE DONE

Sergeant Sam Guzzi kept the case open, and a file on it was always right on the top of his desk in headquarters. Not only was he stubborn in the face of advice to let it go, nothing would ever come of it, but he also felt bound to follow all possibilities—he owed it to the town, to the Calandriello family and to Rosemary. In 1971, he sent the hair and a hammer from Zarinsky's car to the state labs for analysis using a new forensic technology, DNA profiling. He had his hopes up, but it turned out that the hair was not from Rosemary, but from the girl found in the Raritan River. Unfortunately, Middlesex County prosecutors, believing they had insufficient evidence, did not pursue it further.

Early in January 1975, a relatively new Monmouth County assistant prosecutor named John T. Mullaney just happened upon the Zarinsky file after his name came up at a regional crime task force meeting. As he read through it, the file made his skin crawl with contempt for this predator that no one had yet brought to justice. Working with the Middletown detectives, Monmouth County investigators and Sergeant Sam Guzzi in Atlantic Highlands, he believed he could prosecute Zarinsky and get him convicted. Six long, long years later, it seemed Rosemary's killer would be put away for good.

The trial, *State of New Jersey v. Robert Zarinsky* for the murder of Rosemary Calandriello, lasted ten days. Despite the efforts of the defense to challenge

the state's evidence and testimony and cast reasonable doubt into the minds of the jurors, despite the fact that most of the state's case was completely circumstantial, assistant prosecutor Mullaney presented a strong case. In his summation, he looked into the eyes and, he hoped, into the hearts of each and every juror as he held their undivided attention. With old-fashioned fire and brimstone, he hammered home the thought, "Every one of you here has daughters. How would you feel if somebody stole one of them away and snuffed the life out of her? And left her body somewhere hidden where you could never find it and weep over it?"

Robert Zarinsky was found guilty of Rosemary's murder and later sentenced to ninety-eight years in prison, where he remains today, at Trenton State Prison.

CRIMINAL FAMILY TURNS ON ITSELF

As the years passed, Zarinsky learned that his father died in 1989, that his wife, Lynn, had divorced him in 1994 and that his mother, Veronica, died in 1995. Whatever emotions he may have felt is of no concern here. But perhaps he was pleased at his mother's death, for she left him the family house—which he kept shut and locked up till neighbors began calling it the "haunted house" or the "monster house"—and all her mutual funds, said to have been valued at more than $150,000.

His only sibling, his sister, Judith Sapsa, married to Peter Sapsa, was not quite so pleased with the financial arrangements of her mother's will. Judith and her husband, figuring Zarinsky would never get to spend the money before he died in prison and would never even notice it was gone, began to slowly embezzle money from the funds. By the time they had helped themselves to a total of $112,000 in 1999, Zarinsky did indeed notice the shortage. He informed the proper authorities who now, ironically, had to work for him rather than against him. Federal investigators teamed with state and county authorities in the criminal case involving the couple in theft and fraud prosecutions.

When Judith Sapsa saw the depth of the serious trouble she and her husband were in, she offered to make a deal. In return for reduced charges and significantly reduced prison time, Judith Zarinsky Sapsa would testify against her brother with the detailed firsthand knowledge she had of his and his cousin's joint robbing of an automobile dealership in Rahway back in 1958 and the shooting and killing of police officer Charles Bernoskie. She named her cousin, Theodore Schiffer, whose fingerprints were matched to

the thumbprint left on a can of oil at the crime scene. Both would testify in trial against Zarinsky, telling how Mrs. Veronica Zarinsky dug bullets out of both their bodies that night and swore the family to secrecy. Eventually, the jury found Zarinsky not guilty, not because they believed he was innocent, but because the evidence and testimony was unreliable. Cousin Teddy pleaded guilty and was given a fifteen-year sentence, which he was allowed to serve in a Pennsylvania prison, to be close to his home and to avoid the risk of accidentally meeting his cousin, Zarinsky, in the same prison one day.

TALES OF MIDNIGHT BURIAL

Peter Sapsa had some talking to do with Monmouth County authorities, as well, and he hoped it would be to his benefit in the embezzlement charge. Sam Guzzi was invited to be there to hear his tale:

> *Bobby asked me to drive him some place from his house in Linden. This was in late August 1969, around the time that girl disappeared. He put some stuff in the trunk and we drove late at night into Hunterdon County, some spot near Readington, or around there someplace. We came to a field and he told me to stop and just stay in the car. Out of the trunk he took a pick and a shovel and a big brown burlap bag with something inside. After a while he came back with the tools and put them in the trunk. Then we drove back. I never asked him about it, knew better not to, and kept it to myself till now.*

Detail of the Calandriello family gravestone. Agnes was Rosemary's mother, and she had the angel and Rosemary's name and birth year added after her daughter's abduction and death. *Author's collection.*

Hope Endures

Authorities took Peter Sapsa to the area, hoping that the drive out there and a walk around might help his memory to find the right spot. But no luck. Things had changed so much in thirty years, it had been dark and memories fade after so long. Sam Guzzi had such hope, and now that hope was gone.

Yet hope was not completely gone for Rosemary's mother, and many others, too. In Mount Olivet Cemetery along Chapel Hill Road in Middletown Township there stands an expression of hope today. There is a cold, gray family headstone whose hardness is softened by the image of a little watchful angel with hands in prayer and the soft words "Rosemary Calandriello" with 1952, her year of birth, and an empty space where her date of death will go...someday.

Evil Continues Its Misery

Even locked away in Trenton State Prison, Zarinsky's evil continued to bring torturous misery into the lives of others. In 2001, he was put on trial for the murder of policeman Charles Bernoskie back on November 28, 1958. However, he was acquitted of the charge. Bernoskie's widow, Bette, acted fast and filed a wrongful death suit in civil court. In August 2003, she was awarded $9,500,000 plus interest. Then, from the murderer's assets, $154,000 was seized and Bette Bernoskie gave it all to her six children. Still locked in prison, but with access to its legal library, the murderer appealed the award and the appellate court ordered the money be returned to him, on the grounds of an inadequate defense. The NJPBA stepped in and raised the money needed to satisfy the court's order.

Finally, there came relief. The Monmouth County prosecutor indicted Zarinsky on March 11, 2008, for the murder of Jane Durrua, a thirteen-year-old girl from North Middletown who disappeared November 4, 1968, and was found murdered. Appearing in court to answer the indictment's charges, Zarinsky was handcuffed, strapped to a prison hospital gurney and breathing oxygen with difficulty. This was not just for show. Robert Zarinsky, finally, was awaiting the end of his evil life in misery!

A Murdered Girl, Unknown but Not Forgotten

December 11, 1988

While local resident volunteers of Atlantic Highlands were gathering to clear a parcel of land along Sandy Hook Bay to be used as a bicycle trail, a volunteer found and attempted to pick up what he initially thought to be an old plastic ball. To his horror, it was actually a human skull. The date was December 10, 1988. The discovery was brought to the attention of the Atlantic Highlands Police, and an investigation was initiated.

> *An unidentified white girl, about 15 to 18 years old, was murdered and her body buried in a deserted area along the beach in Atlantic Highlands between 1973 and 1975 by an unknown person or persons.*

The Monmouth County Medical Examiner's Office and the State of New Jersey Medical Examiner's Office together determined that the skull was indeed human. The area of the find was then excavated. Sand was sifted and all material was examined. The Atlantic Highlands Police Department, the Monmouth County Prosecutor's Office, the New Jersey State Police, the Monmouth County Medical Examiner's Office and the New Jersey State Medical Examiner's Office were assisted by the Connecticut State Police and the Burlington County Medical Examiner's Office, both of which had a possible interest in the case.

An analysis of the skeletal remains showed that they were from a Caucasian female between fifteen and eighteen years old, five feet, one inch to five feet, four inches tall and weighing 100 to 120 pounds.

A botanist expert in crime scene analysis was called in to review the scene and the clothing found with the skeletal remains. It was determined that the

A Murdered Girl, Unknown but Not Forgotten

body had been in that same location for approximately the previous fifteen years, thus placing the time of death sometime between 1973 and 1975.

Detective Sergeant John Amici and Detective Adam Hubeny of the Atlantic Highlands Police spearheaded the investigation into the identification of the dead girl. The skeletal remains were mapped out and entered into a national police computer system. This allowed all law enforcement departments to compare their missing persons data with that for the unidentified girl.

There was a media blitz as local print and television reporters from New Jersey and neighboring states converged on Atlantic Highlands and, for four straight days, covered all aspects of the recovery of the remains and the results of their analysis. A special program called *Crime Beat* highlighted the case. Despite all the media exposure, no identification could be made.

In 1992, with the assistance of the FBI, a clay reconstruction was made over the recovered skull. The result is a possible resemblance of the face of the unidentified girl before her death. This sound scientific procedure has led to identifications in many other cases. Hundreds of photographs were distributed throughout the area and shown in newspapers and on television. The image was sent to all police departments, but without success.

Most every state in the United States and law enforcement agencies around the world were involved. Interpol followed several leads in England. All were without success.

In 1997, parts of the skeleton were sent to LabCorp in Research Triangle Park, North Carolina, for mitochondrial DNA profiling. In September 1998, the results of the DNA profile were available. A comparison was made with that of a missing Burlington County girl, last seen in Mount Holly in 1975 and matching the physical description. No match was made.

At the time of the discovery of the remains, there was great anticipation in Atlantic Highlands that they would prove to be those of Rosemary Calandriello, who vanished in 1969, despite the difference of dates: 1969 versus 1973–75. Analysis of the dental impressions of the two girls and the clothing recovered from around the skeleton showed conclusively that this was not Rosemary Calandriello, for whose murder Robert Zarinsky, of Linden, New Jersey, had been tried and convicted in 1975.

The murder of this unidentified girl occurred some thirty years ago. The case is still open and not forgotten by either the Atlantic Highlands Police Department (732-291-1212) or the Monmouth County Prosecutor's Office (1-800-533-7443). Nor is this girl forgotten by unnamed others in the world for whom she was a daughter, a sister, a cousin, a friend and not just an unidentified female skeleton found on the beach at Atlantic Highlands.

REFERENCES

1. IN SEARCH OF CAPTAIN KIDD'S TREASURE

Beecher's Illustrated Magazine, July 1871.

2. "THE MOST WANTON, CRUEL AND UNPRECEDENTED MURDER" OF JOSHUA HUDDY

Horner, William. *This Old Monmouth of Ours*. Freehold, NJ: Moreau Bros., 1932.

Walsh, Maya. *Captain Joshua Huddy*. Historical Society of Highlands, 1997.

3. "I AM STABBED…I AM KILLED FOR THE MONEY."

Beck, Henry Carlton, Rev. "Highlands Tragedy Gave Rise to Tale of Recurrent Corpse." *Olde Monmouth Times* 1, no. 1 (January 1999).

Monmouth Inquirer. "The Trial of James P. Donnelly for the Murder of Albert S. Moses," 1857. [Booklet publication of the original newspaper columns recounting the trial in remarkable detail.]

Morris, A.H. (member of the jury). "The Highland Tragedy, Trial and Execution of James P. Donnelly." *Monmouth Inquirer*, 1888.

New York Times. "The Trial of James P. Donnelly," August 7, 1857 and January 9, 1858.

Saretzky, Gary, ed. "Murders in Monmouth." Monmouth County Archives.

Sunday Newark Star Ledger, April 18, 1954.

4. "THE DOCTOR WAS DEAD. BLOOD WAS ALL OVER THE PLACE. MURDERED!"

Monmouth County Archives Coroner's Files. Re: Maack, 1873.

New Jersey State Census 1875 for Middletown, Highlands of Navesink. Tavern Licenses Highlands, pp. 65–75.

REFERENCES

5. "WELL, I WILL KILL YOU WHEN WE GET HOME."

Monmouth County Archives. Autopsy Index under "Melvina Harmon": Report of Death of Melvina Homan.

————. Coroner's report. Report of Death of Adolph Homan.

————. Testimony of Ellen Hayes, Dr. George Brown, Edward Burdge and Daniel Caulkins of Twin Lights.

New York Times, August 18, 1888.

Red Bank Register, August 22, 1888.

6. A GRIMM TALE OF ATTEMPTED MURDER

New York Times, October 27, 1889.

7. MRS. VAN NOTE'S DEAD BODY COMES TO SHORE

Red Bank Register, June 8, 1904; June 22, 1904; and June 15, 1905.

8. "MAY GOD FORGIVE US!"

Monmouth County Archives. Coroner's Inquests 1907. "Unnamed Female."

Red Bank Register, January 9, 1907 and January 16, 1907.

U.S. Census, Middletown, New Jersey. Michael Callahan. 1900.

9. MURDER IN THE HEART OF TOWN

Red Bank Register, March 7; October 10, 1923; and May 13, 1925.

10. A WITNESS SAW NOTHING AS HERBERT O. MEISTERKNECHT WAS MURDERED

Atlantic Highlands Journal, November 17, 1927; and January 4, 1934.

New York Times, November 16, 1927; and November 17, 1927.

Red Bank Register, November 16, 1927; and November 23, 1927.

11. CROOK COPS BEAT OUT A CONFESSION FOR RAYMOND WADDELL'S MURDER

Atlantic Highlands Journal, January 8, 1931; and July 16, 1931.

New York Times, March 31, 1931.

Red Bank Register, January 7, 1931; April 1, 1931; and July 15, 1931.

12. THE KILLER LEFT A KING OF SPADES AT AL LILLIEN'S MURDER

New York Times, October 17, 1929; October 21, 1929; and March 25, 1933.

Red Bank Register, October 23, 1929.

13. "STORMY WEATHER SINCE MY BUFF AND I AIN'T TOGETHER"

Asbury Park Press, August 23, 1933; August 26, 1933; August 28, 1933; August 29, 1933; August 30, 1933; August 31, 1933; September 1, 1933; and September 20, 1933.

References

Atlantic Highlands Journal, August 23, 1933; August 28, 1933; September 7, 1933; and October 19, 1933.

New York Times, August 27, 1933.

Red Bank Register, August 30, 1933.

"Stormy Weather." Words by Ted Koehler, music by Harold Allen. First sung by Ethel Waters in the Cotton Club Revue, 1933.

14. A Colored Man's Murder Goes Unsolved

Atlantic Highlands Journal, April 12, 1934.

Red Bank Register, April 11, 1934.

15. The Blind Judge Sees Justice in Muriel Walker's Homicide

Atlantic Highlands Journal, August 22, 1935.

Red Bank Register, March 28, 1935.

16. Evil on Neighborhood Streets

Asbury Park Press, August 10, 2003.

Bergen Record, August 21, 2003.

Courier, August 28, 1969; September 4, 1969; and November. 27, 1969.

Newark Star-Leger, August 19, 1999; August 22, 1999; August 24, 1999; August 26, 1999; September 1, 1999; December 9, 1999; January 15, 2000; March 11, 2000; November 18, 2000; May 19, 2001; May 26, 2001; and June 2, 2001.

17. A Murdered Girl, Unknown but Not Forgotten

Monmouth County Prosecutor/Crime Watch. www.shore.co.monmouth.nj.us/01190_prosecutor.

ABOUT THE AUTHOR

John P. King is a former Red Bank Regional High School teacher of Latin and French. Since 1995, he has been researching and writing about the history of Highlands, New Jersey, almost exclusively. King and his wife of thirty-eight years, Helen, ran a bed-and-breakfast for a number of years from their historically important old home, which inspired his interest in all aspects of the history of Highlands. Over the years, he has contributed a large number of historical vignette–style articles to local papers and has written or edited some half-dozen history books on Highlands.

Currently, King is in the final revision of a historical novel set in Highlands during the Revolutionary War and the early nineteenth century. He can be contacted at ka2fka2f@yahoo.com.

Visit up at
www.historypress.net